A
NEWBURYPORT
MARINE *in*
WORLD WAR I

A
NEWBURYPORT
MARINE *in*
WORLD WAR I

THE LIFE AND LEGACY OF EBEN BRADBURY

BETHANY GROFF DORAU

THE
History
PRESS

Published by The History Press
Charleston, SC
www.historypress.com

First published 2018

Manufactured in the United States

ISBN 9781467139427

Library of Congress Control Number: 2018932089

Notice: The information in this book is true and complete to the best of our knowledge. It is offered without guarantee on the part of the author or The History Press. The author and The History Press disclaim all liability in connection with the use of this book.

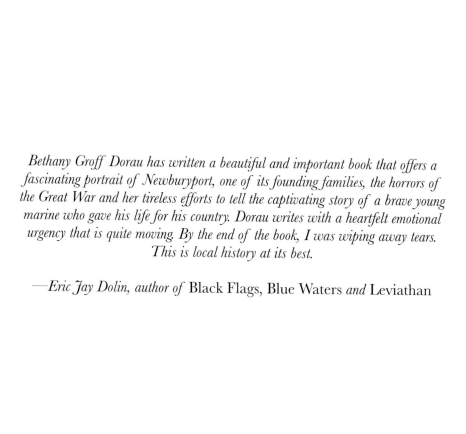

Bethany Groff Dorau has written a beautiful and important book that offers a fascinating portrait of Newburyport, one of its founding families, the horrors of the Great War and her tireless efforts to tell the captivating story of a brave young marine who gave his life for his country. Dorau writes with a heartfelt emotional urgency that is quite moving. By the end of the book, I was wiping away tears. This is local history at its best.

—*Eric Jay Dolin, author of* Black Flags, Blue Waters *and* Leviathan

To Steve, George, Michael and James, who have given so much, and to David Hall, because I promised.

CONTENTS

Acknowledgements 11
Introduction. The Dead Letter 13

1. Bradbury Beginnings: 1634–1793 19
2. Eben the Silversmith and Eben the Whaler: 1793–1847 23
3. A Romance, a Shipwreck and a Gold Mine: 1852–1859 29
4. A Wedding, a Baby and Death in the Family: 1859–1864 37
5. The Last Voyage and a Homecoming: 1864–1878 41
6. Eben the Pharmacist: 1879–1885 47
7. The Only Eben in Town: 1885–1888 53
8. The Corner of Pleasant and State: 1888–1891 59
9. A Wedding and a Baby: 1893–1897 63
10. A Son Who Was Named Eben: 1897–1900 67
11. The New Century: 1901–1910 73
12. Away from Home: 1910–1912 85
13. Newburyport High: 1912–1916 91
14. Two Senior Years: 1916–1917 95
15. First to Fight: April–July 1917 101
16. The Last Letter: July 1917–February 1918 107
17. To the Front: March–June 1918 113
18. Belleau Wood: June 6–June 12, 1918 117
19. Immediate Report of Casualty: June 12–September 29, 1918 123
20. The Aftermath: 1918–1974 129
21. You Will Take It to Him: 2015–2017 135

Bibliography 151
Index 153
About the Author 157

ACKNOWLEDGEMENTS

E ben Bradbury would have remained a casual acquaintance, and my life would have been poorer as a result, if not for the trust placed in me by Steve Bradbury. The richness and beauty of the family letters would have been lost to me without George, the lavender farmer, who even paid for postage. Michael Johnson, who flew to meet us with forty pounds of diaries in his suitcase, has enriched our lives with his friendship. I will never forget Constant Lebastard's kind attention to us during our visit to the Aisne-Marne American Cemetery. To him, and to all those who dedicate their lives to the care and remembrance of Americans buried abroad, we all owe our gratitude.

I am eternally indebted to Leana Gallagher, Doris Noyes and the other members of the 1919 Reading Club who read, organized, transcribed and encouraged. The friends and family who attended the transcription party made an arduous task seem manageable and possible. To Emma Fisher, and to Eben's own Newburyport High School for lending her to me, I owe sincere thanks. In this modern age, where questions can be shared with hundreds of people at once, I have been helped enormously by contacts on Facebook, and because of this, Eben has thousands of new virtual friends.

Cynthia August, who photographed much of the ephemera and locations in this book, is not only an extremely talented artist but a dear friend who has come to love this family right with me. Amanda Ambrose made connections I would have missed and gave freely of her time, talent and sparkling wit. Eric Jay Dolin offered spot-on advice and support. All of my friends and

co-workers at the Spencer-Peirce-Little Farm and Historic New England understand the obsessions of a history nerd, and they put up with my endless stories with good cheer. Arleen, Sara, Susan, Ellie, Ginny, Mike, Stephanie, Jim, Gus and all the rest of the gang, thank you for listening.

Susan Edwards and Emily Shafer from the Museums of Old Newbury scanned images, hunted down documents, found bits of valuable information and were generally wonderful. Michael Mroz at the Custom House Maritime Museum has been a valuable resource from the beginning of this project, sneaking me in after hours to stare rapturously at the wall of captains and offering advice and contextual information. Jane Fielder at Kimball Union Academy and Kathy Krathwohl at the Massachusetts College of Pharmacy and Health Services were generous with their time and provided crucial images and information. Thank you to the Newburyport Public Library.

My children grew up with Eben, in a way. We say good morning to him when we pass his memorial stone on our way to school. They, along with my parents, Gary and Jean Uhlig, have shared the experience of finding this family along with me, and I am grateful for their patience and enthusiasm. James Dorau is my traveling companion, first reader, writer's widower, staunch advocate and best buddy. Thank you, Jimmy, for everything.

I was on deadline for this book at a very difficult time for our family. Sarah Spalding, Tim Fountain, David and Laura Dietz, many dear friends and, of course, my editor at The History Press, Michael Kinsella, helped to make it a bit easier.

Introduction

THE DEAD LETTER

On an unusually hot summer afternoon in May 1918, Eben Bradbury came in from the garden, washed his hands and sat down at his desk to write his son a letter. The elder Bradbury was fifty-seven years old and a fixture in Newburyport's downtown. Sunday was his day at home, but the other six days a week Bradbury spent in his apothecary shop, a landmark establishment on the corner of State and Pleasant Streets, four blocks from his house in a nearly straight line. His life had revolved around the shop, with its trade placards (Shaker Roots & Herbs! Lactated Foods! Patent Medicines!) and scalloped awnings, since he was in his twenties, before he courted his wife, before the birth of his children, first a round-faced, near-sighted girl and then a slender, sharp-eyed boy. He had put off the writing of the letter in part because even on a Sunday, there was a great deal of work to do. Eben and his wife, Lizzie, like so many of their neighbors, supported the war effort by growing a substantial amount of produce in the backyard of their house on Bromfield Street. For weeks that May, temperatures hovered in the eighties, and the garden was precocious and demanding. Bradbury had been raking, weeding beds of young peas and radishes and setting tomato plants. He had intended to plant corn that day, but a threatened thunderstorm and the oppressive heat finally drove him indoors, where he settled down to write his weekly letter.

Eben Bradbury's sharp-eyed son was also named Eben. He was the fourth Eben Bradbury, the only one who was not actually christened Ebenezer. Since the Bradbury family had involved itself in every aspect

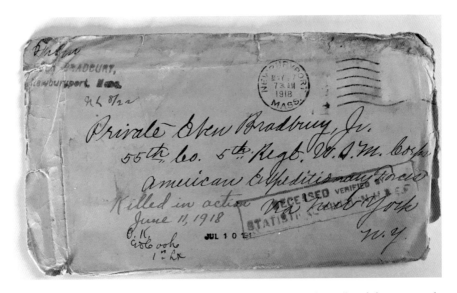

Letter from Eben Bradbury to his son on May 27, sent "all over France" and then returned in September or October 1918. *Author's collection.*

of Newburyport's economic, social and political life since the seventeenth century, since before Newburyport existed, the same-name problem had been mitigated by the use of titles (his father was Captain Bradbury) and unusually long generations. The captain had led a rich and adventurous life. He had returned to Newburyport from gold mining in California and whaling in the South Pacific and married his hometown sweetheart, Mary Todd, at forty-four, producing his only child and namesake at the astonishing age of forty-six. His wife, four years younger, outlived the captain by twenty-three years and lavished affection and attention on her only son, a surprise blessing in her late middle age. Eben, the pharmacist, had himself married late, focused as he was on succeeding in the cutthroat pharmacy trade. He was thirty-seven when his son Eben was born. His father, the captain, had died two years before. So in Newburyport in 1918, there were two Eben Bradburys, and since one was younger, he was assigned the title of Jr., though he was actually the fourth. Among his friends, he was known as Bunny, a diminutive nickname for a boy who never quite reached five feet, five inches. To him, his father was and always had been "Pa."

Eben wrote this letter with some difficulty, a bit of melancholy creeping in, even as he kept his tone cheerful for the sake of his son. He stuck with

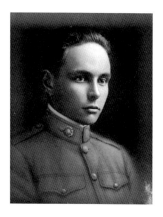

Eben Bradbury Jr. in marine uniform, May 1917. *Museum of Old Newbury.*

familiar topics—weather, family and baseball—but there were hints of the worry that had consumed him since his son left Newburyport a year earlier. Though the garden was fine, the apple and peach trees were blighted by early frost. Boys he had known all their lives were leaving for the front. The last line of the letter finally spelled it out: "We haven't heard from you for seven weeks tomorrow. Love, Pa."

Eben Bradbury folded the letter in thirds, put it in an envelope and addressed it in his distinctively large, jagged handwriting: "Private Eben Bradbury, Jr. 55th Co. 5th Rgt., U.S.M.C., American Expeditionary Forces, via New York, NY." He stamped his name in the top left corner, pausing to add "From" above it, affixed a three-cent stamp and a Blue Star flag to the back of the envelope and mailed it from the post office on Pleasant Street on his way into work the following day. The letter is postmarked at 7:30 a.m.

Eben's letter to his son arrived in France as the German offensive around the Aisne River was well underway. American soldiers and marines were being sent to the front lines to shore up the disintegrating French army, and all over the country, the stalemate that had characterized the previous years of war was breaking up in bloody attacks that searched for weakness and then hammered through. The letter began a circuit around France that would last all summer, a father's hope and worry searching for its source. Along the way, Lieutenant E.D. (Elliot) Cooke, who had assumed command of Eben's 55th Company, scrawled his name in pen under the return address. Another hand crossed out the "55th Co" in red pencil, while another later added his initials and the date, August 31. Finally, in September, the futility of the journey was confirmed with a stamp. A long, black, rectangular box covered Eben's handwriting. DECEASED verified by STATISTICAL DIVISION H.A.E.F. (Headquarters American Expeditionary Force). Another hand added in red pencil, "Killed in action, June 12/18." The letter, nearly illegible now, made its way to the central mail office in Paris and joined at least three other letters from Eben to his son, similarly marked.

In October, a young Red Cross volunteer from Newburyport finally received her orders abroad. Eleanor Little, daughter of Newburyport's leading banker, had turned her considerable energy and talent to war work

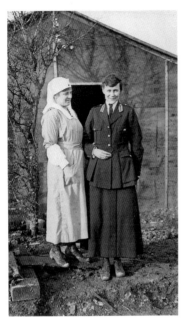

Eleanor Johnson Little (later Baker),
Red Cross nurse who found Eben's
dead letters and sent them home.
Courtesy Baker family.

as early as 1914. She collected bandages and baby baskets for Belgian orphans, hosted fundraisers for the Red Cross and first learned and then taught battlefield first aid. When she arrived in France at long last, however, she found herself stranded in Paris without an assignment. "To occupy myself I worked sorting mail at the Marine Post Office, where by extraordinary chance a letter directed to Eben Bradbury, which had been all over France, came into my hands." Eleanor Little knew Eben Bradbury well. The two were nearly a dozen years apart, but both came from prominent local families, and their mothers were frequent social colleagues, judging flower shows together and attending meetings of women's clubs. Miss Little paused for a moment to think of her friend and his family and then sent the letter on its long journey back to Newburyport.

At least four letters that Eben had written to his son had gone "all over France" and made their way back to the white house on Bromfield Street by the end of the year. There is no way to know which was the very first to arrive, as the order in which they were mailed, one as late as July 9, does not necessarily correspond with the order in which they returned. We know that at least one was still languishing in the Paris marine post office in late October, when it was sent on by Miss Little. What is certain is that one of these letters arrived in early September, marked, like this one, "Killed in Action." There was no ceremony, no solemn uniformed man arriving at the door, no telegram. The worst news a parent can hear arrived by accident in the mail, three months late.

Eben and Lizzie Bradbury left Newburyport, now the scene of unspeakable sorrow, in 1924 and never came back. Three hundred years of the Bradbury family was not enough to compel them to stay. They settled in central California, in the small town of Hickman, near their daughter Marguerite. The returned letter, along with the family papers, diaries, paintings and mementos that Eben could not bear to leave behind,

traveled to California with them. Eben Bradbury never reopened the letter he had written to his son in May 1918. It was still sealed with the Blue Star flag stamp when he died in Modesto, California, in 1941. Sometime after his death, Eben's letters, collected over his lifetime and passed down from generations before, were bundled up and tied with string. They grew musty and damp; ink began to fade and pencil to wear away.

In 2015, ninety-seven years after Eben Bradbury came in from his garden and asked his son for news, the letters were put up for sale at an auction in California. They had no bidders. The auctioneer threw them in with another lot, purchased by the proprietor of a local farm shop where antiques and vintage items were also offered for sale. The bundles made their way to this shop, where the buyer's father asked to look at them. Intrigued, he searched online for the name on the top of the bundle, Eben Bradbury, and found me. Two days later, the farmer carefully packed the bundles in Ziploc bags and bubble wrap and sent them back home to Newburyport. Eben Bradbury's letter to his son was opened and read at my table, two blocks from his house on Bromfield Street, nearly a century after it had been sealed and sent on its sorrowful journey around the world.

This, above all, is the story of generations of an American family, a story that begins at the end, with the most devastating loss imaginable. The life of Eben Bradbury Jr. is part of a thread that leads back through centuries, through whalers and gold miners and silversmiths and witches, mothers and lovers and babies and ordinary people living in extraordinary times, all part of the soil and sea of Newburyport. Eben Bradbury Jr., a young man who everyone in town would have known, left his family and city on April 17, 1917, and never came back. Over the years, despite efforts to honor him in a permanent, public way, he was largely forgotten. In his last letter home, Eben Jr. asked to be remembered. To remember him is a sort of homecoming, a tie of memory and affection to the place he loved. But to really remember him, you must first meet his family.

BRADBURY BEGINNINGS

1634–1793

There was no daily paper in Newburyport on Sunday, June 28, 1914, and even if there had been, the news of the assassination of Archduke Franz Ferdinand, heir to the Austro-Hungarian throne, would likely have missed the print deadline. As it was, the next morning's paper was dominated by news of the resignation of the Newburyport High School principal Walter Andrews, the death of a Salisbury girl in a motorcycle accident and a devastating fire in Salem. Under a large photograph of a family made homeless by the Salem fire, and just above news of a seizure of illegal liquor in Byfield, there appeared a short paragraph with the headline "Heir to Austrian Throne Assassinated." For those of us with the benefit of hindsight, it seems impossible that this momentous occasion, the spark that lit the fire of World War I, would receive so slight a mention, but Newburyport, and the United States, had a lot of other things on its collective mind in June 1914.

Eben Bradbury was in his pharmacy on that Monday morning when the papers arrived, but if he noticed the trouble brewing in Europe, he made no mention of it in his diary. His only son, a student at Newburyport High School, was sixteen years old, but the United States was in no mood to involve itself in a foreign war and had no capacity to do so in any case. The United States had a traditional aversion to forced military training or service and a small standing army. The idea that his son would ever join a war in Europe must have seemed remote at best. This is not to say that the Bradbury family was unfamiliar with military service. Newburyport and

Arms of Bradbury of Essex.

ARMS.—Sab. a chevron ermine between three round buckles, argent, the tongues hanging downward.

CREST.—A demi-dove volant arg. fretty gu. holding in beak a slip of barberry, vert.

Bradbury coat of arms. *Private collection.*

its citizens had played a part in all military conflicts since its earliest settlement.

Newburyport in 1914 was a small city of around fifteen thousand people, an offshoot of a larger town, Newbury, established in 1635 during the first wave of British settlement in North America. Thomas Bradbury, Eben's seventh great-grandfather, left London in May 1634, sent over by his great-uncle Sir Fernando Gorges to act as agent over Gorges's sprawling landholdings in present-day York, Maine. Though he was acting agent in Maine, affixing his name to some of the first deeds recorded in the future state, Thomas Bradbury married Mary Perkins in Salisbury, Massachusetts, in 1636, and it was in Salisbury, just across the Merrimack River from Newbury, that he ultimately settled and began his family. Most of Thomas and Mary Bradbury's neighbors in Salisbury were from Newbury families, reaching over the river in search of land. Thomas took the freeman's oath in Salisbury in May 1640 and was allocated land the same year, his fortunes rising as his family grew. All but one of the eleven Bradbury children survived the perilous early years, and six of these married and had large families of their own. Their father held a series of positions of trust in the town, serving as town clerk, justice of the peace, constable, representative to the general court and county court recorder. He laid out town boundaries, settled disputes between neighbors, was the captain of the local militia company and "to crown all, he was, of course, licensed as an innkeeper or retailer. He was an easy, legible and industrious penman, and evidently a man of sound judgment and more than ordinary ability. He was sometimes called 'Judge' in Salisbury," according to John Beck's *Captain Thomas Bradbury and His Wife Mary Perkins.*

Thomas and Mary's children married well, and when Mary was swept up in the witchcraft hysteria of 1692, it was her son-in-law Major Robert Pike who ably, though unsuccessfully, defended her. Her husband's years of tireless service to the town, the county and the colony and his strident defense of his now-elderly wife were not enough to save her from accusation and imprisonment. On July 26, 1692, Mary Perkins Bradbury was brought before

the dreaded court, accused of bewitching several of her neighbors, whom she "Tortured, Afflicted, Consumed, Pined, Wasted, and Tormented." She had shape-shifted into a blue boar; spoiled casks of butter; and flown out to sea, where she perched on a ship and tormented her neighbors in spectral form. Mary steadfastly declared her innocence, calling on her "brethren & neighbors that know me, and unto the searcher of all hearts for the truth & uprightness of my heart." Thomas pleaded with the court to spare his wife:

> *Concerning my beloved wife, Mary Bradbury, this is what I have to say: We have been married 55 years, and she hath been a loving and faithful wife unto me unto this day. She had been wonderful, laborious, diligent and industrious in her place and employment about* [bringing] *up our family which have been 11 children of our own and four grandchildren. She was both prudent and provident, of a cheerful spirit, liberal and charitable. She being now very aged and weak, and grieved under many afflictions, may not be able to speak much for herself, not being so free of speech as some other might be. I hope her life and conversation among her neighbors has been such as gives a better or more real testimony than can be expressed by words.*

In July 1692, a petition signed by 118 of Mary's neighbors appeared in court, testifying that she was a good Christian, a good neighbor and a good person. It was not enough. On September 9, 1692, Mary Perkins Bradbury was convicted of witchcraft and sentenced to hang. What happened next is a matter of some debate, but what is known is that Mary Perkins Bradbury escaped from prison, perhaps through a bribe or an orchestrated prison break. Some believed she flew out of her cell. After her ordeal, Mary returned to Salisbury, where her sentence was later commuted. Thomas Bradbury and his "dearly and well-beloved wife" died five years apart, both living to the remarkable age of eighty-five. Eleven years after her death, in 1711, her heirs were paid a settlement of twenty pounds for her wrongful conviction. By then, her descendants already numbered in the hundreds and would soon swell to hundreds of thousands, later counting Ralph Waldo Emerson, Ray Bradbury and astronaut Alan Shepard among then.

Thomas and Mary's eldest son, Wymond, born a scant eleven months after their marriage, was already dead by the time of his mother's witchcraft trial after having been stranded on the island of Nevis, in the West Indies, one month before the birth of his third child and namesake in May 1669. This Wymond, a minister, and his wife, Maria, had nine children. The seventh of these, a son named Theophilus, made the

move across the bridge by 1730, marrying Ann Woodman that year in Newbury. He invested heavily in the maritime success of the town, making his living as a coastal merchant and becoming part owner of three trading sloops, the *Speedwell*, the *Success* and the *Molly*. Though he owned land and a sawmill as far away as Harpswell, Maine, he kept his family in Newbury, dying there in 1764, just one week after the citizens of the town's waterfront successfully petitioned to become a separate town.

The enterprising yeomen of Newbury, initially intent on establishing a stock-raising enterprise, soon realized the benefit of their position at the mouth of the Merrimack River, and a thriving maritime enterprise grew up around the wharves established there. In 1763, the merchants and tradesmen of Newbury petitioned the general court to be allowed to break away from the rest of the town, as their interests had so completely diverged. This petition was signed by two sons of Theophilus Bradbury: Jonathan, a shipwright, and another Wymond, a ship joiner, whose interests, like their father's, were in the maritime trades. Their petition was granted on January 28, 1764, and the new town of Newburyport was born. Though initially the smallest town in Massachusetts, with only 2,800 residents living in 357 homes, just one decade later, it would play a major role in the American Revolution. By the eighteenth century, the Bradbury family, or at least this branch of it, had deep roots in Newburyport, and in the following century, Bradburys served Newburyport as legislators, sea captains, judges and merchants, their fortunes ebbing and flowing with their town.

The first Theophilus Bradbury lived to see his namesake grandson, son of Jonathan, born in 1763. He also passed his name into a family replete with Thomases and Wymonds. By the time his grandson was born, there were half a dozen Theophilus Bradburys in Newburyport, the most famous being his youngest son, a noted lawyer and congressman. His grandson Theophilus took a different path, learning his trade in the State Street shop of silver- and goldsmith Joseph Moulton, twenty years his senior and best known for his gold jewelry and silver tableware. By 1796, the pair had developed a lucrative partnership, with a busy shop, Moulton & Bradbury, on Merrimack Street "near Somerby's Landing," at the bottom of State Street, where they specialized in plated buckles. Theophilus, like his grandfather and many Newburyport merchants and tradesmen, also owned shares in several merchant vessels.

Chapter 2

EBEN THE SILVERSMITH AND EBEN THE WHALER

1793–1847

The first of the four Eben Bradburys was born to Theophilus and Lois Pillsbury on July 31, 1793, his name carefully recorded in the birth register among the Knight and Lunt and Swett and Peirce babies of that year. Newburyport was still overwhelmingly populated by the heirs of the first settlers at the end of the eighteenth century, and Eben's birth was recorded on the same page as Charlotte Bayley, born November 1. The Bayley family, settled in Newbury by 1650, would follow a parallel path to the Bradbury family in Newburyport, and the Eben who shared a birth book with a Bayley girl would have a grandson, Eben the pharmacist, who would marry another Bayley girl nearly a century later. Family connections in Newburyport ran deep.

This first Eben was his father's oldest son and was soon brought into the family business. Theophilus and Eben Bradbury went into the silversmithing business by 1815, offering to their fellow townsfolk an intoxicating array of goods bearing the distinctive eagle and Indian mark of Bradbury and Son. The *Newburyport Herald* advertised "soup, sauce and cream ladles, table and tea spoons, sugar basins, tea pots, cream pots and pitchers…of their own manufacture." Trade was brisk, and at the end of the year, twenty-two-year-old Eben wed nineteen-year-old Nancy Merrill, who had been born in Newburyport but had moved with her family to Frankfort, Maine, on the Penobscot River. One year later to the day, on December 10, 1816, Nancy gave birth to the couple's first child, a son who they named after his father. Babies followed nearly every year after, eight of them in thirteen

years. Four of these babies, three boys and a girl, did not survive their first full year. Nancy Merrill Bradbury never recovered from the last birth, a baby girl named Anna Mary who lived for less than two months. Nancy died at home on January 13, 1832, age thirty-five. Eben Jr. was fifteen when his mother died, the eldest of the four children who had survived infancy. Within five months, his father married again, this time choosing thirty-three-year-old Mary Tappan, with whom he would conceive an additional ten children, six of whom survived to adulthood. The broad span of his parenting years allowed Eben an unusual relationship with his children; he began early on to correspond with his eldest son as an equal, sending Eben Jr. a letter from Pennsylvania in 1837 (Eben Jr. was eighteen), asking him to return to Newburyport from his mother's family in Frankfort to host his uncle

Ebenezer Bradbury (1793–1864) was a silversmith with his father, Theophilus, then a Massachusetts state legislator and eventually state treasurer. *Private collection.*

and remarking that "the infants," Eben Jr.'s new half-siblings, "both have intermissions of the 'Summer Complaint.'"

The elder Eben did not last long as a silversmith, preferring instead to follow in the footsteps of his great-uncle, the noted jurist Theophilus, who served as a congressman from Massachusetts during the tumultuous years that followed America's independence. Eben began in local politics, advocating for public education and serving on town committees while building a machining business on Fair Street. He sold this business in 1826, and for two decades between 1828 and 1848, he was in and out of state legislature as the state representative from Newburyport. By 1845, he was a member of the executive council, and in 1847, he was the Massachusetts Speaker of the House of Representatives. The peak of his legislative success came in 1849, when he was appointed state treasurer, though the process was grueling. A January 4, 1849 letter to Eben Jr. offers insight into the machinations of state government and the uncertainty of his position and also into the intimacy Eben shared with his son: "Sargent [his opponent] and friends have been actively at work, and instead of being at home yesterday…I should have been here [in Boston] setting things right. I have missed the support of numbers of mutual friends merely by his or his friends' first applications." He closed the letter with a gloomy assessment of

his chances: "If I fail, as I probably shall, it will prove that I am a political Jonah, and that my friends had better make no more attempts to stem the adverse tide against me. I am very affectionately your father, EB." Despite his assurance of failure, Eben Bradbury was made state treasurer, a position that he held for the two years that his Whig Party held power, and he moved to Newton with his large family to shorten his considerable commute.

In the 1850 census, fifty-seven-year-old Eben had eight children at home in Newton, ranging in age from seven to seventeen. Thirty-four-year-old Eben Jr. was still listed, as he was as yet unmarried and still part of his father's household, but next to his name is the notation "On the Ocean." In 1850, the younger Eben was thousands of miles away, a state of affairs that had become familiar in the years since the death of his mother.

Sometime between the death of Nancy Merrill and the birth of his first half brother, sixteen-year-old Eben Bradbury signed on to the Newburyport whaling ship *Merrimac*. He would be gone for three years and seven months, and upon his return, he made his way to New Bedford, where the opportunities for a talented young man were plentiful. By the 1830s, New

The trademark of Bradbury & Son silver, circa 1815. *Private collection.*

Bedford's whaling fleet was the largest in the country, and shipping agents responsible for securing crews for these ships scoured the port towns of New England for young men eager for adventure and perhaps, like Eben Jr., happy to leave an overcrowded household. Newburyport, with its long maritime history and its growing population, was an ideal place to recruit young men, and newspapers carried notices almost daily claiming there was good money to be had in New Bedford. An 1833 letter from "A Parent" in the *Newburyport Herald* appealed to parents of young men considering a life at sea. The long voyages of whale ships were actually critical for the "preservation of good morals and good habits," it argued, because "if a person intends to follow the sea for a living, the longer he is absent, the better, for he is out of reach of temptation, and at the end of ten years he would be worth more money than if he were frequently in port." For a young man like Eben Jr., the monetary benefit may have proved more alluring than the building of character, and for a talented young man in the whaling boom of the mid-nineteenth century, the shipping agents' claim that "there is as constant and unceasing a manufactory of officers as there are oil and candles" could prove to be true. Though Newburyport did outfit a few of its own whaling vessels, like the *Merrimac* on which Eben made his first voyage, and the harbor reports indicate that there were frequent whalers in port, New Bedford was the place to go if one wished to get aboard a whaling ship quickly.

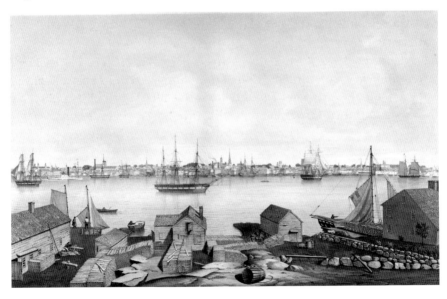

View of Newburyport from Salisbury, 1845. *Private collection.*

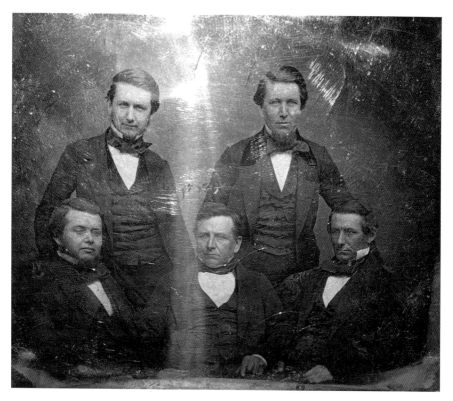

Eben Bradbury I (*center*) and sons. *From left to right*: John Merrill, Albert, Theoph and Eben. *Courtesy Michael Johnson.*

date Newburyport newspaper, and was visited by an astonishing number of people he had known back home, looking for a friend in the strange landscape of California and help settling claims of their own. He did what he could, offering meals and advice in exchange for packages from his father and siblings and, of course, Mary. In 1856, he also received an unexpected letter, the first ever, from his youngest full brother, Albert, eleven years his junior. Albert was five years old when his oldest brother left home, and with years at sea and in California, the two were virtual strangers. Eben Jr. found it charming that Albert found it necessary to "break the ice" and promised to be a good friend to his little brother, the fourth and final surviving son of Nancy Merrill. As it turned out, Albert would prove to be a good brother, a good uncle and a spectacular stepson, caring for their father's widow, Mary Tappan, in his house in Dexter, Maine, until her death in 1881.

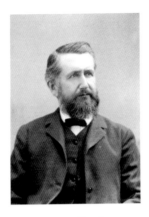

Albert Fayette Bradbury
(1827–1896), Eben's
youngest full brother and
frequent correspondent.
Private collection.

By the fall of 1856, Eben Jr. had left Downieville and taken up mining in China Flat, about six miles farther up the Yuba River. He considered bringing Mary out to California but argued that it would be pointless, as he did nothing but work and she would be lonely, though he wished she would be "mistress of my household, as humble as it is." At all times and in all places, he thought of Newburyport, telling Mary that the whole town of China Flat was the length of Beck Street, where they had grown up, and that he missed the sea. "I never was so long before without seeing salt water....How much longer it will be before I see it again I cannot tell." He missed the sea, missed his home and missed her. "Mary, I will agree to take your part in any of your troubles when it is in my power to do so. I wish I was where you could call upon me now." That December, alone in his cabin in China Flat, frozen out of his claim and worried about how much money he had spent on bacon, potatoes and coffee, Eben Bradbury Jr. turned forty years old.

Finally, in the spring of 1857, Eben literally struck gold, or at least he managed to coax a sufficient quantity out of the rocky soil to pay off his debt and send John Merrill some capital to invest. His success also illuminated the source of some fraternal tension with Theoph. In April, Eben wrote of his windfall to Mary: "You must not whisper a word of this to anyone, for if you do, I am afraid it will get to Theoph and [his wife] Emily, and then it would be published, surely, besides calling on me for assistance. You may think I am growing selfish, and perhaps I am, but I don't want to help support another man's wife in her extravagance. If Emily had never seen California, I would have been a hundred dollars better off." Eben fended off the inevitable question of when he would return, arguing with a gambler's confidence that he was on the verge of a big find: "Mary, I know we have been separated for a long time, but by staying away some more time, we may have more to live on than if I came home now. My prospects now look better than they have since I have been in this country." It had been five years since they had seen each other, and with Mary now in her late thirties, the chances of having a family with her adventurous paramour grew more and more distant. By the end of

the year, she had asked him the burning question, "When will you turn your face home." He answered at length, reminding her that he had never promised to come home at any particular time and he was not going to give anyone a date until he was darn well ready and certain. She didn't ask again, even as months and then years stretched on.

On his forty-second birthday, December 10, 1858, Eben impressed himself by learning to make a "plain but palatable" mince pie. He wrote excitedly to Mary that other miners nearby had heard of this feat and come to call on him in some numbers, and he now felt that every Sunday, the only day he spent in his cabin, would be spent cranking out pies for the neighbors. It would explain the brevity of future letters, he quipped. He was quite a homebody, and between work and baking, he had also taken to raising chickens, and they kept him company. "I have not been as far from home as the length of Middle Street." To his brother John Merrill, he was not in a joking mood. The rift with Theoph seemed to be deepening, and Eben counted the weeks since he had heard from him in every letter to John. "As I did not offer him assistance, I suppose he has concluded to drop our correspondence." Eben Jr.'s bitterness also carried an edge of guilt. Theoph had followed his brother to California as a partner, but they had separated during a particularly difficult time. Once the claims began to pay off, Eben had not invited his brother back into the company and had asked both John Merrill and Mary Todd to keep his success a secret from Theoph. Though he was under no legal obligation to include his brother in his claim, Eben spent a good deal of time explaining his omission to his family, blaming his brother's wife, Emily, for his decision not to recall Theoph to the claim.

As the new year began, however, Eben Jr.'s luck was running out. He had gambled and lost, spending most of his substantial earnings on supplies and equipment for the earthworks and sluices needed to coax gold from the mines, and he was finally ready to consider turning his face toward home. "Everything here is dull, especially the weather." He was owed money, but since nobody was finding gold, there was little chance of his being paid back. His father asked if he would consider coming home and taking up silversmithing, the trade of the elder Eben's youth. It would require an investment of about $2,000, he said, and allow his son to settle down. Eben Jr. shot back a frustrated response: "If I do not collect [the debt] before I come home, I might as well consider it as good as lost." He could not ask Theoph to collect it in March, the earliest he expected to be paid back, since "he would be likely to use it up and give me credit for

it," and Eben was through extending credit to his brother. He would write in March and let his father know whether he would consider returning home. "For all that this is a country where precious metals are found in such abundance, I suppose there is not another country in the world where money is so scarce."

Chapter 4

A WEDDING, A BABY
AND DEATH IN THE FAMILY

1859–1864

Eben's last surviving letter from California is from July 1859. In it, he made no mention of coming home but described the frantic scramble of his company to make up for lost time after a cold, snowy winter and a muddy spring. Sometime in the two months after this letter, Eben Bradbury Jr. packed up his gear, collected what debts he could and walked to San Francisco, where he boarded a steamer for the twenty-nine-day journey to New York, then caught another ship to Newburyport and sailed home at last to Mary Todd, who had waited for seven years for her fiancé. On November 1, 1859, Eben and Mary Todd were married at the Old South Church on Federal Street in Newburyport by the Reverend Ashbel G. Vermilye, their names entered into the Newburyport registry in the precise, spidery hand of Eleazer Johnson, city clerk. Mary was nearly thirty-nine and newly fatherless, caring for her mother and her disabled brother, Elias, at the house on Beck Street. She had never lived anywhere else. Though Newburyport was the only real home that Eben had ever known, he had not lived there for more than a few months since he was sixteen years old. With John Merrill in residence in a hotel in Boston, Theoph still scratching out a living in California and even his youngest brother Albert moved to Maine, Eben took his bride to stay with his father, who had moved to Milford, an inland town in Worcester County, where he had been given a lucrative position as a municipal judge. Four of the youngest of his expansive brood were still at home, and it may have proved a tight fit for Eben Jr. and Mary, or they may simply have had a better offer.

Bartholomew Wood was Mary Todd's first cousin, and as luck would have it, he lived in Milford, down the road from the Bradbury family. By June 1860, Bart Wood and his wife, Jeanette, had added Eben Jr. and Mary to their household, along with four young children of their own and a boarder. Eben and John Merrill kept up a snappy correspondence between Boston and Milford, but with regular visits between the brothers and their wives, their letters were shorter and dealt mainly with business interests. John Merrill had invested some of Eben Jr.'s gold money in bank stocks, and it seems that Eben was living off these investments. In late September 1860, he sent his brother a quick update on a visit to Milford by Charles and John, their stepbrother and cousin, lamenting that "Mary was quite unwell the whole time they were here." Eben Jr. may not have known, and only about four weeks along, Mary herself may not have been sure, but she was most definitely pregnant.

It is difficult to know how Mary Todd, long-suffering fiancée and new wife of Eben Jr., felt about the prospect of motherhood at forty. Certainly her family situation was complicated by her husband's unemployment and their temporary quarters at her cousin's house. It must have seemed nearly miraculous, however, at a time when most women had their first children in their early twenties, to have been given the chance to be a mother, after all the years of waiting. The news of his impending fatherhood spurred Eben Jr. into action, and he began making arrangements for his child to be born in Newburyport, as receipts from December 1860 indicate that he was preparing to furnish a house.

Though 1861 may have been a happy time for Mary and Eben, as her pregnancy seemed to progress without trouble, it was a time of tremendous upheaval for the United States of America, and the Bradbury family was not left unscathed. Southern states began to secede in February 1861, and in April, Confederate troops attacked Federal troops at Fort Sumter in Charleston Harbor. On May 10, Mary Todd received a letter from her second cousin Harriett, daughter of Eben's uncle John Bradbury, who had first claimed the land in California and died in San Francisco. She was working on clothing for Mary as she came to the end of her pregnancy and after, a dressing gown and cape "to be rather loose in the back and drawn in around the waist," to adjust with her changing body. After pages of chatty updates on dress makers and the romantic endeavors of other family members, Harriett's letter took a sober turn. "Charles, you may have heard, has enlisted.…John and Walter are drilling every night preparatory to being called upon to enlist." The youngest of these three, the romantically named

Old South Presbyterian Church, where the Bradbury family attended services for more than a century. *Private collection.*

Walter Scott Bradbury, was her half brother and lived in Cambridge with Harriett and their two oldest brothers. Harriett and her brothers were orphans, having lost their mother in childbirth and their father in San Francisco, and all of the siblings had formed a household and were extremely close, with Harriett, the eldest sister, as the maternal figure to her brothers. All three of her brothers did enlist, but Walter Scott Bradbury never came home. He died of malaria in 1863, while fighting with the Forty-Fourth Massachusetts Regiment in New Bern, North Carolina. "Are not these gloomy times?" she asked her cousin. "I find it hard work to keep up courage and a cheerful heart—everything looks so dark." When the news came that Walter Scott had died, Harriett was inconsolable, her grief at the loss of an adored youngest boy an eerie foreshadowing of another devastating wartime loss half a century later. "Our sorrow has come upon us like an armed man," she said, "and we are bowed down with grief for our loss. When I think of how precious and dear he is and has always been to us, I feel overwhelmed with grief. It is too hard to give him up."

This was all in the future, of course, but May 1861 was most certainly a gloomy time for Mary Todd, regardless of the national crisis. On May 10, she received a letter from her sister Sarah, describing in detail the painful death of their youngest sister, Ann Greenleaf Todd Smith, just after the birth of her eighth child, a daughter. "I don't think she had felt well one day since her babe was born....I suppose [her husband] John will have one of his sisters take care of the children....I pity him and the children very much." Coming as it did just weeks before the birth of her first child, the death of her sister must have been a sobering reminder to Mary of the very real risk that women took with every birth. Whatever the reason, she decided to send for her mother in Newburyport and have her baby in Milford. On June 6, 1861, the third Ebenezer Bradbury was born in a rented house in Milford. The baby's name and birthday were entered into the town record, with the father's profession listed as "Mariner." Despite his new baby and his years

of prospecting, pie-making and loan-sharking in California, Captain Eben Bradbury had only one real calling. He was headed back out to sea.

In November 1861, former state treasurer Ebenezer Bradbury, the first of three who now carried that name, packed up his family and moved slowly back to Newburyport, visiting friends and relations along the way, before commencing work on a house in Salisbury. Mary was also back in Newburyport with the baby by the early months of 1862, and Eben had found a whaling ship, the brig *Eschol*, out of Beverly and had been hired as captain. The Civil War was a dangerous time for Yankee whalers, as Confederate privateers, eager to cripple Northern industry in any way they could, seized cargoes of valuable whale oil and spermaceti. Thanks to a combination of vigilance, luck and skill, Eben managed to avoid the fate of one of his sister ships, captured and burned in the Azores as Eben hid his ship behind a neighboring island.

Mary Todd and baby Eben moved back to her childhood home on Beck Street with her mother and unmarried brother William, who had taken on their father's block and pump trade, and then to a rented house on Titcomb Street. With his father gone, and any possibility of a sibling gone with him, little Eben settled into a happy toddlerhood as the center of his mother's world. Sometime in 1862, Eben had his first portrait done, to the great delight of his adoring extended family. In February 1863, Eben's aunt wrote to Mary Todd from Frankfort, Maine, "We all think from the picture that little Eben must be a very beautiful child, and they all say he is as active and smart as he is handsome. What a comfort he must be to you now that Eben is away." Though he may have been a beautiful baby, "Ebby," as his family called him, was also often sick, beginning in the winter of 1863. The loss of mothers and children is a constant theme in the letters that passed back and forth among the women of the Bradbury family. In 1864, the death of a young cousin from diphtheria reminded Eben's aunt of his mother, Nancy Merrill, and how the loss of her daughter, Ann Maria, hastened her death. "Poor Nancy—it was more than she could bear. I have been really anxious, fearing that she would settle into that melancholy, depressed state of mind that your own mother did, when she lost her little daughter."

As it turned out, the surprise passing of the year was not a child but the patriarch. On June 19, 1864, the first Ebenezer Bradbury, politician, judge, silversmith and father of eighteen, died suddenly of a heart attack. He was seventy years old and "greatly lamented by a large circle of friends."

THE ONLY EBEN IN TOWN

1885–1888

In March 1885, Eben Jr. received a letter from his aunt Sarah, John Merrill's wife, who had left their home in Ipswich after her husband's death to live in Boston. She gently chided him for not visiting her when he was in town for school and offered updates on the health and romantic prospects of a half dozen cousins and friends. Then she got to it: "George Williams [Captain Eben's old shipmate] was in to see me this evening and told me he had been down to Newburyport….He called to see your father, he said he looked badly, said he came to the door in his stocking feet, his legs were so swollen he cannot get his shoes on his feet….He should not be surprised if he dropped away at any time." Eben Jr. had learned his lesson about leaving work on short notice, and he waited until Saturday, March 7, and caught an early train to Newburyport. He came back to South Weymouth on Monday, checked in at the pharmacy and went to his night classes, then got back on the train to Newburyport. On Wednesday, he wrote in his diary, "Father is on his death bed. Limbs badly swollen and very painful." On Friday, it was all over. "Father failing rapidly, passes away at 4:30 p.m. having his senses to the very last." Captain Ebenezer Bradbury, whaler, gold miner, oldest of eighteen, husband and father, was buried in Oak Hill Cemetery, with his youngest brother Albert and his only son as pallbearers. Eben Jr. would spend a decade as the only Eben Bradbury in town in nearly a century.

He and his mother spent a week entertaining aunts, cousins and friends, and his diary reveals that during this sad time, he had one visit that was a pleasure. Every day that week, he "called on L.C.B." Elizabeth "Lizzie"

Chase Bayley was from the neighborhood, growing up on Middle, Prospect and Lime Streets, always within a block or two of the Bradbury family. She was the daughter of William H. Bayley, who was a master mariner and, though fourteen years younger, had been a friend and associate of Eben's father, serving as the secretary of the Newburyport Marine Society during the years that Captain Eben was a relief committee chairman. Lizzie's mother, Lucy Chase, was from another distinguished old family from West Newbury with ties to the Bradbury family, their names weaving through each other's lineage like the roots of a gnarled tree. Like many mariners, William Bayley retired from active voyages in middle age, becoming first a lumber dealer and, by the time Eben was visiting their house at 64 Lime Street, the overseer of the almshouse. Earlier in the year, Eben had gone to a skating party in Newburyport and noted that he did not see his "inamorata," a cryptic word for female lover, but he was also calling on his friend and classmate Kate Greenleaf at that time. Lizzie Bayley was twenty-five in 1885 and Eben was twenty-three, footloose and free. He was working and studying hard, going to baseball games, watching yacht races and hanging out with friends from high school, from his old job in Holbrook and new friends in Weymouth and Boston. He took a week's vacation alone in August, traveling to Providence and Provincetown, where he stayed at expensive hotels, watched the young ladies swimming and took fashionable tricycle rides.

Eben had plans, and though they did not include settling down just yet, they did seem to always include Newburyport. Part of the draw was always his mother, whose loneliness and boredom were increasingly present in her letters to her son. She spent the Fourth of July missing her husband and watching the neighbors have their parties. She was still caring for a handful of aunts, "miserable for some days" and filled her letters with reports of illness and death, though that had always been part of her biweekly report. One aunt was particularly dull. "I have been talking with Aunt Mary who is sick in bed, or rather she has been talking with me about Aunt Rebecca and other things not particularly new." Eben's eyes were bothering him, and she was worried about that too. "Doesn't it tire you very much to play baseball?" she asked. Eben had loved baseball since he was first in school, and he had played in high school. His eye problems were a mystery, likely severe allergies, as his vision was fine when he was not having his "troubles," but they prohibited him from playing ball in a more serious way. Eben went to Newburyport and Haverhill ballgames whenever he was home during the season and traveled to see the Boston Beaneaters play at the South End Grounds, at the corner of Columbus Avenue and Walpole Street. Despite

William H. Bayley (1834–1919), sea captain, secretary of the Newburyport Marine Society and grandfather. *Private collection.*

his busy schedule, he was always home to vote, and in 1885, he used the opportunity to go to Lizzie's house for dinner. At the end of the month, he was back, noting that "[I] ate my Thanksgiving dinner at Middle Street in the evening at L.C. Bayleys." Eben was not home for Christmas, however, and Mary Todd missed her son terribly. "It has been a lonely day for me," she said. "What amusements have you tonight in Weymouth? Have you been confined all day?" Eben did not return home again in 1885 but ushered the year out in his diary: "Goodbye old year. May our good deeds be remembered and our evil deeds forgotten."

The next two years passed quickly. Eben worked for Eldbridge Nash in South Weymouth and went to Boston to attend classes at the Massachusetts College of Pharmacy every Tuesday night. He and his mother exchanged long, regular letters, hers filled with maternal concern about his health and lists of dead and dying friends and relations and always updates on the miserable aunts on Boardman Street, whose condition never seemed to improve. It wasn't all gloom and doom, however. Mary Todd still had a sense of humor, even about the aunts, whose company she secretly enjoyed, relishing the days when she found them "bright and chatty." Aunt E, the crankiest of the lot, was Elizabeth Horton Heavey, Mary Todd's mother's youngest sister. She had married Edwin Heavey in 1836 and had a daughter who died at one year old. Her husband was committed to the insane asylum in Ipswich by 1850 and died, still in the asylum, in 1852. She had been a widow for over thirty years, living on Boardman Street with her cousin Mary and occasionally her other sister Abby. Her gloomy disposition was perhaps justified by her life experience, and Mary Todd herself was certainly no optimist. Widowed at sixty-four, with four of her five siblings already dead, her own experience had reminded her over and over again that fate was capricious and often cruel. "That is the way of life," she said to her son in December, "well one day and the next crippled for life." Eben had always been precious to her, but as the years went by, she treasured every word from him. "Write of

everything you think will interest me of yourself and the rest of the world," she wrote, and he obliged faithfully, exactly once a week.

Eben came home to Newburyport once or twice a month, leaving the shop on Saturday afternoon and returning late Sunday night, and frequently visited with Lizzie Bayley, though he also escorted several other young women home from skating parties and church fairs. He went into Boston more frequently as well, to the opera, to the World's Museum and, of course, to any baseball game he could work into his schedule. On April 8, 1886, Eben met Lizzie in the city, and they went to the Hollis Street Theater together to see the German comic opera *Nanon*. It was the first of many dates in Boston for the pair, evidence of their growing connection and also of certain boldness on Lizzie's part. On October 28, he wrote cryptically in his diary, "Took my usual trip to Boston and for the first time we occupied our own room." It is possible that this refers to new buildings for the Massachusetts College of Pharmacy, but Lizzie would sometimes come down by train to meet him in Boston. It is possible that this was their first night spent together, after a summer of walks to Plum Island and into the rural quiet of "Old Town" Newbury. If so, it was a bold move for both of them.

Eben took course examinations in the spring of 1887, his mother's worried letters fluttering in as he studied and worked and tried to push through crippling pain in his eyes. In March, Mary Todd was thinking about Captain Eben on the second anniversary of his death: "All last week, his sickness and distress was before me....You cannot imagine how lonely I am." In addition to caring for the aunts, walking over a mile through the mud and dust to the house on Boardman Street that they stubbornly refused to leave, she was also managing deadbeat tenants on Smith Street who kept falling behind on their rent "through drink and sickness."

Eben spent almost every weekend with Lizzie that summer, spending the long evenings with her at Salisbury Beach, Plum Island and at home with her family. He still took a week to travel alone to North Conway, sleeping in and enjoying the mountain air. In the fall, with his pharmacy licensing test scheduled for December, Eben left South Weymouth for his last posting, to Dudley and Draper pharmacy in Melrose, which he found decidedly underwhelming. He had enjoyed working with Eldbridge Nash, who had proven to be a kind and considerate boss, and he had also gained in maturity and responsibility since his unpleasant experience in Holbrook. On November 28, 1887, Eben "packed my trunk and regretfully stole away." After a week in Melrose, he wrote, "My impressions with the store have not improved with longer acquaintance. There is a lack of neatness."

Eben was beginning to have some very specific ideas of how he would run a shop of his own.

Eben took his final exams at the end of December, passed with flying colors and said an enthusiastic "Au Revoir!" to the year in his diary. He was restless and eager to begin the next chapter in his life. Eben seems to have returned to Newburyport in March or April 1888, as there are no more letters in the collection from his mother. His diary from that year is also missing, but in the *Newburyport Daily Herald* on July 18, 1888, in the local happening section, there was an extraordinary announcement: "Eben Bradbury has purchased of Frank Woodwell the Merrimac Pharmacy. He will continue the business at this old and well-known stand." The newspaper was eager to give this hometown boy a boost in his new endeavor: "Mr. Bradbury is a young man of ability and high character. He has had ten years' experience in various first class drug stores, and is in every way competent to carry on the business." Eben's first pharmacy position had been at the Atkinson Pharmacy at the corner of State and Pleasant. Now, ten years later, he was home in Newburyport, it seemed for good, and he was a licensed pharmacist with his own shop on the most visible corner in downtown Newburyport.

THE CORNER OF PLEASANT AND STATE

1888–1891

Eben threw all of his considerable energy into his new business. He signed up with his alma mater as a preceptor and was sent an apprentice, Francis Alphonso Donahoe, in the fall. It was the culmination of many years of hard work, saving and planning, but Eben Bradbury was young, and his clientele needed some convincing. He went on an advertising rampage in the *Newburyport Daily Herald*, beginning with a front-page announcement on July 23, 1888: "I am prepared to furnish all articles usually found in a first-class drug store. With ten years experience in drug stores of the best standard, I feel fully competent to attend to orders in this department." Eben ran this advertisement daily in July and August and then tapered off to weekly as he took up ad space to hawk specific potions and products.

Though an ideal location, the building at the corner of State and Pleasant Streets had fallen into disrepair and had changed hands several times over the previous decade. A photograph taken two years after he bought the business shows a building under repair and still in need of attention. The roof flashing is askew, and scaffolding hugs the front façade. Still, front and center, the largest in the jumble of titles and advertisements on the building is the shop sign, his name in gold leaf. The sign is large and expensive, with mortar and pestle relief, visible from down the street. Eben had little time for social calls in his early years at the store, but his diary of 1889 noted visits to Lizzie and the aunts at Boardman Street and walks to the waterfront and across the river to Ring's Island in Salisbury. Eben Bradbury was home,

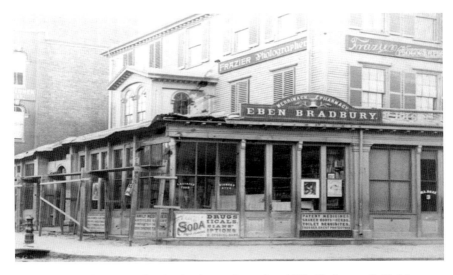

Eben Bradbury Pharmacy shortly after its purchase, circa 1890. *Newburyport Public Library.*

living with his mother at 59 Middle Street, just around the corner from his shop, and he had the pleasure of Lizzie's company when he could steal away, but he seemed to be in no mood to settle down.

In 1889, John Merrill's widow, Sarah, who had been so fond of Eben as a boy, wrote with exciting news. John Merrill had been working on a Bradbury family genealogy when he died in 1876. Thirteen years later, a cousin in Maine had hired a researcher to complete and publish the book. It would have photographs of his grandfather and uncles and a full genealogy of Bradbury children since Thomas and Mary begat the first Wymond Bradbury in 1637. Eben knew a great many of the people in the book personally, in the great web of cousins, aunts and uncles that surrounded him in Newburyport, and he pored over it when it arrived. To Eben Bradbury, and to his son yet to come, their ancestors were close at hand at all times, spoken of by old folks, remembered as handsome or miserly, kind or profligate, but always remembered, always nearby. Eben and his mother clipped obituaries and kept them in small pharmacy envelopes designed for medicinal powders, and later in life, Eben continued his uncle's work, writing to researchers across the country, looking for the grave of his great-uncle Walter Scott Bradbury, who had died of malaria during the Civil War; copying birth and death dates from family Bibles in his distinctive script; and updating his own list as family members passed. Aunt Sarah did not live to see her husband's book in print. Her death was

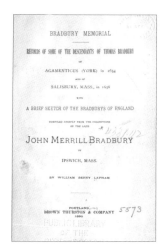

Left: Title page of the *Bradbury Memorial*, written by John Merrill Bradbury and published after his death. *Private collection.*

Below: Eben Bradbury Pharmacy after renovation, circa 1894. *Newburyport Public Library.*

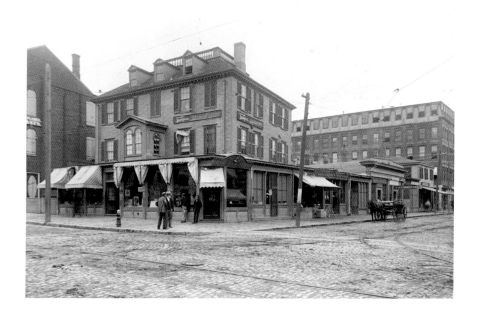

announced in the paper under the headline "Outlived Many Kin." Her grave at Old Hill next to John Merrill was one of many that Eben would visit faithfully on Memorial Day for years to come.

Since Eben was now living with his mother, their letters, the source of so much information about the family, ceased, so what can be known of his life is gathered from his diary (years of which are missing), from the

newspaper and from letters between other family members. It is curious that in surviving letters between Mary Todd and her loquacious family, no mention is ever made of Lizzie as a romantic prospect, though she and Eben had clearly been spending time together for years. In 1890, Eben found little time to keep up his diary, and Lizzie is not mentioned at all. True to Bradbury family form, the few notes he kept were on death and disaster—a man buried in a mountain of coal, a train accident, a man killed instantly when a hay bale fell from the loft and broke his neck. Eben also recorded attending concerts and dances, "as a spectator," perhaps alone, and at the end of February, he noted ruefully that "Newburyport is now the muddiest place in the country." Eben joined the tennis club, playing so well that his name often appeared in tournament lists in the newspaper, and his mother fretted from the parlor at 59 Middle Street about the toll of such physical exertion on his health, but Eben was on a roll. In May 1891, he could finally afford long-deferred renovations to the store and closed for two months, announcing triumphantly on July 18 that "it has been refinished and refurbished." Eben took out a top-of-page advertisement in the Newburyport City Directory, sharing the space with his uncle William Todd, who was running the family block and pump business, and William Creasey, painter and paper hanger and Mary Todd's brother-in-law. Eben also took out daily advertisements in the *Newburyport Daily Herald*, selling cures for shattered nerves, constipation, scrofula and "female debility."

Chapter 9

A WEDDING AND A BABY

1893–1897

By the next year, one of the much-maligned aunts, seventy-nine-year-old Elizabeth Chase Horton Hervey, moved to 59 Middle Street with Mary Todd, and Eben Bradbury moved out. He purchased a small house on Bromfield Street, rekindled his romance with Lizzie Bayley and, on June 6, 1893, eight years after their visits began, "Eben Bradbury and Miss Lizzie, daughter of Captain William H Bayley, were quietly married at their future place of residence." Reverend Hovey of the Old South Presbyterian Church, where the Bradburys had worshipped for generations, presided over the ceremony. Their names were entered in the marriage record in city hall, the oldest pair (save one) to tie the knot in June that year; Lizzie was thirty-three, Eben thirty-one. Like his parents, Eben and Lizzie had taken their sweet time. Lizzie, who had grown up in the Prospect Street Congregational Church, became a Presbyterian by marriage, and they walked the short blocks from Bromfield Street to meet Mary Todd at the beautiful, high-steepled church on Federal from then on. Five months later, Lizzie's parents celebrated their thirty-fifth anniversary with a big party on Milk Street. They had not waited, marrying at the more typical ages of twenty-four and nineteen, and their anniversary party offers a window into their world. "For thirty-five years they have lived happily together," read the announcement in the newspaper. The mayor and many city officials attended the party, along with many members of the United Order of the Golden Cross, a mutual aid society whose members were pledged to temperance. The party was attended by nearly one hundred

people, and the couple "entertained their visitors in a royal manner…one and all wishing them a long life." Lizzie was the oldest of three, and her younger brothers, Harry and Frank, joined the widening circle of friends whom Lizzie brought to the house on Bromfield Street. In 1894, the couple began hosting whist parties, Eben enthusiastically noting winners and losers in his diary. They also took long walks together of several miles, leaving the city for the beach, the rural quiet of Old Town Newbury and even sometimes walking the ten-plus miles to and from Amesbury to see cousins and friends.

The spring storms of 1894 were some of the most severe in decades along the Atlantic coast, and Eben, who had inherited his father's seafaring obsession with weather and wrecks, made detailed notes about the wreck of the *Jennie M. Carter*, a three-masted schooner laden with paving stones that washed up on Salisbury beach with "not a soul on board." Eben and Lizzie went with hundreds of other people to see the mysterious wreck, and Eben recorded the bodies of the crew as they washed up one by one. In February 2013, I took my family to see the wreck of the *Jennie M. Carter*, visible on Salisbury Beach after a ferocious storm, unknowingly following their path to see the same wreck 119 years later. On May 5, 1894, Eben's uncle William Todd, block and pump maker, with whom he had shared a page in the city directory and whose house had always been open to his sister and her son during her husband's long absences, dropped dead at age sixty-five in his shop at 87 Water Street at 10:15 a.m. Eben noted this death in his diary, and condolence letters poured in to his mother, the oldest of the six Todd siblings and the only one still alive. "It must have been a great shock to you," wrote her sister-in-law, "and to his poor wife. I pity you both very much." William's widow, Phebe Plumer, outlived her husband by two decades and was an intimate companion and friend to Mary Todd, a lovely, light-hearted adventurer to balance out Mary's tendency to loneliness and melancholy. She was also Eben's favorite aunt and a regular guest at their house on Bromfield Street.

In the summer of 1895, the couple vacationed at Sawyer Cottage on Salisbury Beach with another couple, their absence from town important enough for a note in the paper. They loved the beach, not for swimming or sunbathing but for the sociability of long, warm evenings on the porches of the grand hotels and pavilions of Plum Island and Salisbury and Rye and for the long, chatty walks that they shared. Eben was a happy newlywed, calling his wife "Mrs. B" and "Mother Lizzie" and recording with deep satisfaction several "perfect nights" and "enjoyable times." If "Mother

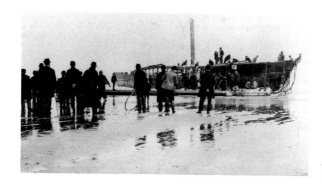

Wreck of the schooner
Jennie M. Carter, 1894.
Museum of Old Newbury.

Lizzie" was pregnant during their first year, there was no baby born, and Eben made no note of an illness. It may have been simply an expression of fondness and hope, which was realized on March 23, 1896, when a healthy baby girl, Marguerite Todd Bradbury, was born.

Marguerite's birth announcement came in the form of a humorous note in the social pages of the *Newburyport Daily Herald*. On March 25, Marguerite was invited to a party thrown for the young son of H.P. Mackintosh, a lifelong friend of the family, but "as the young lady is but a day or two old, the invitation was necessarily declined." Mary Todd's cousin Hattie relished the opportunity to tease her about the new arrival. "I thought it about time for you to be 'Grandma,' and a paper received from Eben tells us that a little daughter has arrived. Do you feel younger?" Lizzie was an energetic and active mother, taking the baby with them to visit in Boston and Jamaica Plain, with Eben making careful notes of their departures and safe returns in his diary. In 1897, Eben and Lizzie started a whist club at their house, and their parties became a record of their circle of friends and family. William H. "Father" Bayley was a regular guest, as were Lizzie's brother Frank and the family of H.P. Mackintosh.

In the early months of 1897, Eben and Lizzie moved to a house several blocks closer to the pharmacy, at 40 Federal Street. It was actually half of a duplex but was spacious and convenient to downtown and the waterfront and around the corner from both Mary Todd and Lizzie's parents. On February 25, 1897, Eben noted in his diary that he "moved my first load to Federal Street." The move was finished two weeks later, on March 5, and he moved the coal from the cellar of the house on Bromfield Street and said goodbye to the house where he and Lizzie had set up housekeeping and welcomed their daughter. As she passed her first birthday, Marguerite was a happy, healthy baby, a good sleeper and easy traveler, and when she became suddenly ill in May while teething, Eben was deeply concerned,

noting her temperature, her "spasms" and her "looking queerly." He was an engaged and solicitous father to his little "Rita," as his own father had been to him in the brief months when he was not at sea. By May, Eben also knew that his paternal duties would soon increase. Sometime in February, Lizzie had become pregnant again.

A SON WHO WAS NAMED EBEN

1897–1900

That spring, as the family looked forward to a new baby, they also said goodbye to the last full sibling of Eben's father. Albert Bradbury, banker, mill owner and railroad man who had lived in Dexter, Maine, for years, had once been that shy younger brother of a captain and a gold miner, writing to him in California and promising to be an interesting correspondent. Over the decades, he had kept his word, exchanging hundreds of letters with his two eldest brothers and becoming close to his nephew as well. Albert died of kidney failure just shy of his seventieth birthday and was returned to Newburyport for burial alongside his parents and seven of his siblings. Eben was given the responsibility of making all of his final arrangements, even riding to Oak Hill Cemetery in the back of the hearse with his uncle's body and keeping his widow, Frances, apprised of the plan. "It will be a melancholy satisfaction," she wrote her nephew, "but I wish to have every respect possible paid to so good a man....I appreciate your kindness in doing for me, and it is a comfort to have one so reliable to depend upon." Eben, now in his late thirties with an established business, a beloved wife, a healthy child and another on the way, had become not only a full-fledged adult but also the Newburyport representative and errand boy for a host of aunts and cousins who had moved away or were otherwise in need of help to manage their local business. He received letters from his aunt Harriett asking him to check on her family tombstone, which she heard was crooked. He found a stonemason to repair it. When his aunt Elizabeth Hervey died after her long years of oppressing Mary Todd with her enthusiastic melancholy, he handled inquiries into her estate from distant relations from as far away as Tacoma,

Washington. He purchased and mailed books of genealogy and local history to relatives across the country, researched ancestors and deeds and helped the homesick feel connected to Newburyport, however far away they wandered. Most letters contained some plea to remember them, to keep in touch, to stay connected. His father's cousin John Henry, after asking for a copy of Joshua Coffin's *History of Newbury* to be mailed to him, explained, "My attachment to my birthplace and all that concerns it, as well as to all my relatives there, is still great." A distant cousin wrote to ask for information about an estate, adding, "I would like to know something of the relatives and those I knew more than fifty years ago, in the old town where I was born." Newburyport was a hard place to leave, and Eben could not imagine living anywhere else.

Through the late summer and fall of 1897, Eben and Lizzie walked, talked, played whist and traveled with baby Marguerite around New England. They went to the opening of the Boston subway and rode it and the trolley as far as Crescent Beach in Revere. Lizzie, eight months pregnant, with a one-year-old in tow, accompanied her husband to Plum Island, to Merrimac and even on a naval ship to Portsmouth, New Hampshire. They were nearly inseparable. Eben noted the wind and weather in his diary and catalogued excursions, accidents and robberies. On Friday, November 12, with an almost biblical reverence, he added, "At 12:15 a.m. was born to us at 40 Federal Street a son who was named Eben." At long last, there would be two Eben Bradburys in Newburyport once again. This Eben was the first of the four who was not christened Ebenezer. He was only ever Eben, with no middle name, a curious tradition shared by all four Eben Bradburys.

The aunts sent their letters asking about Lizzie and the baby boy and sending best wishes and bits of family gossip to Eben. Eben Jr. was "bright and cunning," a charming, healthy baby, and Lizzie recovered quickly from the birth and now toted both babies on excursions with her husband, when the weather permitted. It was a snowy winter, with storms so severe they blew out the attic windows and trolley cars smashed into each other on Pipestave Hill. On February 15, Eben noted the explosion of the battleship *Maine* in

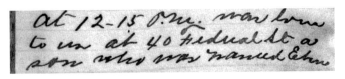

Eben Bradbury's diary entry from November 12, 1897. *Author's collection.*

Chapter 11

THE NEW CENTURY

1901–1910

The new century dawned on a city that had changed significantly since the elder Eben was born in the first year of the Civil War. The steam mills, shoe factories and manufacturing plants that had replaced earlier shipyards along the waterfront attracted a significant immigrant population, and by 1880, fully one-quarter of Newburyport's residents were Catholic, most of them Irish and French-Canadian. By 1890, Russians, Poles, Armenians, Italians and Eastern European Jews were also arriving, adding to the rich cultural life of the city. Many of the young men from the families of earlier settlers left the city as wages dropped, the traditional shipbuilding industry collapsed and waves of recession hit. Still, there were plenty of Bayleys and Bradburys and their ilk in the area, and the social register, at least officially, was dominated by old settler families, even as the face of the city continued to change.

In 1901, Newburyport celebrated fifty years as a city and took stock of how far it had come. The city was electrified and equipped with water and sewer lines, though these did not extend far into the neighborhoods outside the downtown area. With the electrification of the city's streetcars and links to trains and trolleys across New England, public transportation had never been easier and less expensive. It is little wonder, then, that Eben and Lizzie bundled up their children and took advantage of every opportunity for leisure travel, as amusement parks, pavilions, theaters and fairs were an easy, inexpensive trolley ride away. Eben had always been a traveler, in his small way. He was no adventurer like his father, but even when a young student,

he took full advantage of every opportunity to catch a train and see a new place. Until his jaunt to Jamaica in 1900, however, he had never been outside New England and showed no particular desire to travel far. His haunts were local and familiar: baseball games in Haverhill and Boston, Plum Island, Rye and Salisbury beaches, visiting aunts and cousins in Cambridge and Jamaica Plain. Some trips were taken simply for the joy of seeing surrounding towns from the relative comfort of the "electrics." In July 1901, three-year-old Eben and his father went on their first trip alone together, a two-day jaunt to Boston and Nantasket Beach, returning in time to go with Lizzie and Marguerite to Plum Island to see the surf, and in August, the pair hopped on the streetcar and rode it through Haverhill, Merrimack, Groveland and West Newbury just for the fun of it.

Still, despite its advances and amusements, Newburyport at the turn of the century, the time when little Eben Jr. was first becoming aware of his surroundings, was still a gritty, scrappy place, with its share of violence, crime and poverty. The South End, where the family had lived for decades, had areas that were not safe to walk alone at night, and the newspaper carried sensational reports of robberies, fires and the occasional murder. Suicides were front-page news, described in lurid detail and often citing financial ruin or chronic pain as the cause.

Though some of the most intimate details of his life, haircuts, medicines, music lessons and doctor visits can be gleaned through his father's meticulous notes, it is difficult to form a full picture of Eben as a young child. In the few pictures that exist of him, he is unsmiling and serious, with a thin, elegant face and sharp, pale eyes. In one, he sits next to his sister, who has a soft, warm face and slight smile. In another, he is wearing a winter coat that he has clearly outgrown and looks pinched and cold. A family friend later said of him that he was "a chip off the old block," a shadow of his father and a fixture in the neighborhood, always around. He was quiet but not afraid and would defend himself against larger boys in the frequent scraps and tussles that seem to have been a fixture of boyhood in the South End. He was described as a "brave, daring, and plucky lad," recalled a neighbor, "who would stand his ground against any antagonist, if he were imposed upon," but he was prone to colds and had the same trouble with his eyes that his father had as a young man.

Marguerite entered the Jackman School in 1902, followed by her brother in 1904. The school was a modest brick building just a block away from the Bradbury house on Federal Street, a quintessential neighborhood school where every child knew not only one another but also one another's

Above: Market square, Newburyport, circa 1900. Note the prevalence of streetcars. *Museum of Old Newbury.*

Left: Eben Bradbury Jr. and his sister, Marguerite, circa 1905. *Author's collection.*

Eben Bradbury Jr. outside
Jackman School, circa 1906.
Author's collection.

parents. Eben's pharmacy continued to serve the constipated, arthritic and nervous citizens of Newburyport in a modestly profitable way, but his chief joy and preoccupation was his family. Since its founding, the Eben Bradbury Pharmacy had primarily advertised its outlandish miracle cures in the city's papers and directories. Beginning in 1904, another aspect of his business was revealed in his diary, as he began to take his children along to harvest herbs and medicinal plants from the countryside. They walked for miles, collecting herbs, flowers and berries, Eben telling his children stories of old Newburyport and Marguerite imagining skits for school plays, little Eben tagging along, mostly quiet. When he walked alone with his father, they talked about baseball and politics and ships. On April 10, 1904, Rita and her parents walked to the new Anna Jaques Hospital building, then down to the Chain Bridge and back home, a trip of nearly seven miles and at least two hours—not unusual for them. That summer, the family went to baseball games in Newburyport, Haverhill and Boston nearly every week and to the beach twice as often. Eben and his son walked to Ipswich to harvest water lilies, and on one beautiful night in July, the whole family walked to Plum Island so the children could watch the full moon rise over the water, and Eben went swimming for the first time in fifteen years, finding to his surprise and delight that "I had not forgotten how." The Bayley parents had moved in with Lizzie's brother Harry at 65 Bromfield Street, a broad avenue closer to Old Town, where Eben loved to walk, but still only five blocks from his pharmacy. They were frequent dinner guests at the Bromfield Street house, and Eben began to contemplate another move. It was an idyllic time—a steady business, three devoted grandparents, good friends, healthy children and a happy, companionable marriage.

Marguerite and her mother were particularly invested in their church community, appearing as a pair to help at church fairs and collecting money and donations for the poor. Lizzie must have had a particular perspective on such work, as her father had been the overseer of the almshouse in

Newburyport for years, and her work seems to have instilled in her daughter an early generosity. Seven-year-old Marguerite and a few young friends made the paper in 1904, having raised money for Christmas dinners for two hungry Newburyport families. Marguerite loved the spotlight and was a confident speaker and a good singer. She managed to convince her little brother to join her for a duet in the 1905 Old South Easter pageant, and the two of them performed "Daffodil, Bright Daffodil," along with several other numbers with the children's chorus and a solo for Marguerite. Eighty-five-year-old Mary Todd was besotted with her grandchildren, sending clippings of their church and school performances to Albert's widow, Frances, in Dexter, Maine. Frances responded, "We can hardly realize that Eben's children are old enough to take part in entertainments. You must be so very proud of them," then turned a bit morose, hoping that her fellow widow's grandchildren were "a comfort as our general interest become few....[Without them] we should hardly feel we had anything to live for." Both Marguerite and Eben Jr. gave their grandmother ample reason to be proud, as the newspaper reported on small concerts and recitations in which both played a role. Their father began noting expenses for music lessons in his pocket diaries, though as he grew, Eben Jr. began to choose spoken pieces for public performance and left the singing to his sister.

Eben Jr. and Marguerite both attended the Jackman School, since demolished. Eben is in the front row, sixth from the left. *Author's collection.*

On November 10, 1906, the front page of the *Newburyport Daily News* carried a tragic story. Two sixteen-year-old boys "who were great chums" were preparing to go duck hunting in the Plum Island marsh, sharing a ten-gauge shotgun. In the course of loading a shell, the gun fired accidentally, hitting one of the boys in the chest. In the course of several hours, he was rushed to Anna Jaques Hospital and into surgery, where he died of shock and blood loss. His name was Albert E. Bradbury, and he was the grandson of Theoph, who had followed his older brother Captain Eben to the gold fields of California with his much-maligned wife, Emily, half a century before. Death was everywhere in Newburyport in these years. Tuberculosis, influenza, diphtheria, scarlet fever, mysterious debility and childbed infections still claimed the lives of nearly half of its citizens long before old age. Still, the accidental, sudden death of a young man in his prime, particularly a member of an old and well-respected family, was front-page news, and the city turned out once again by the hundreds to pay their respects.

The tragic death of young Albert Bradbury in 1906 also revealed another family story that was not represented in the surviving letters or diaries of Captain Eben's family. It seems that after his estrangement from his eldest brother, Theoph stayed in California until at least 1868, as he registered to vote in El Dorado, California, in that year. By 1870, he was working as a night watchman in a factory back in Newburyport with his wife and their five California-born children, living mere blocks away from Captain Eben and Mary Todd. Their estrangement seems to have been permanent, however, as there is no mention of Theoph or Emily in their letters. Two of Theoph's sons joined the fire department, and his son Lincoln, young Albert's father, was the station chief of Ladder Company Number One. A generation later, however, and in the face of an overwhelming tragedy, the family seems to have experienced a thaw. Eben, Lizzie and their children appeared near the top of the list of mourners in the funeral of young Albert. They had contributed a large bouquet of "pinks" to the mountain of floral tributes.

Not long after this tragic event, Eben began to take the same interest in fire calls in the city as he had in the vicissitudes of the waves and weather. He noted every call, which box was pulled, which company answered and the resolution of the event. He and Eben Jr. also began to follow the Neptunes, a group of men who took Newburyport's hand-powered fire wagons to competitions throughout New England. These "handtubs" were equipped with side rails that were pulled in unison by teams of strong men to power the

spray of water, and as they slowly became obsolete in the field, the interest in competitive handtub musters grew. There is no way to know if this sudden interest in the fire service had anything to do with a renewed kinship with Theoph's family, but a few years later, Eben Jr. would prove his mettle once again by joining the fire department as a junior volunteer.

Though Eben never specifically mentioned alcohol in his diary or entered expenses for wine or beer, he played an interesting role in an ongoing debate in the city over the regulation or prohibition of alcohol. The early years of the twentieth century saw progressive social reform movements throughout the country, and Newburyport was no exception. Meetings of a local Society for the Prevention of Cruelty to Animals were posted regularly in the paper, which also ran notices of those factories that had agreed to a "nine-hour day for ten hours pay" or had shortened their workday without cutting wages. Drinking was increasingly identified as a most dastardly social evil, particularly among the poor and immigrants, and though Newburyport had always been a drinking town with its share of rum distilleries and a tavern at every corner, the temperance movement gained steam here as well. Leading the charge against the evils of alcohol was Eben's elderly aunt Anna Mary, youngest daughter of the eighteen born to the first Ebenezer Bradbury. The venerable Anna Mary had risen to the position of secretary and vice president of the Essex County Woman's Christian Temperance Union (WCTU), dedicated to ending the curse of drunkenness. The WCTU brought all the evangelical fervor of a camp meeting to its efforts, with Anna Mary reporting faithfully to the newspaper that support for the banning of intoxicating liquors was growing and announcing dates and times for the next "temperance agitation," protests that generally took place outside notorious saloons in town. As everyone knew, or at least suspected, since there was no real regulation or ingredient list for patent medicine, the vast majority of the "miracle cures" sold at Eben Bradbury's pharmacy contained significant quantities of alcohol and often narcotics as well. Ironically, one of the pharmacy's bestsellers was a purported cure for alcoholism, the White Ribbon Remedy, which could be slipped into "water, tea, or coffee without the patient's knowledge" and would "destroy the diseased appetite for alcoholic stimulants," even among the "confirmed inebriate." It was even endorsed by Aunt Anna Mary's WCTU, which thanked him for selling a product that helped its "temperance work." In 1906, however, with the passage of the Pure Food and Drug Act, Eben was in a quandary. If he wished to continue to sell profitable patent medicines and tinctures, he would need to do so

EBEN BRADBURY,

APOTHECARY.

— DEALER IN —

Drugs, Medicines, Perfumery, Toilet & Fancy Articles.

PURE LIQUORS FOR MEDICINAL PURPOSES.

Physicians' Prescriptions Carefully Compounded.

60 STATE STREET, COR. PLEASANT, NEWBURYPORT.

Eben Bradbury Pharmacy business directory listing. *Museum of Old Newbury.*

transparently. Hat in hand, Eben Bradbury went before the city council to ask for a liquor license, which was granted in April, and was permitted to advertise "pure liquors for medicinal purposes." No word on how Anna Mary took this news, but several Newburyport drugstores were picketed by the WCTU after receiving their liquor licenses. Eben continued to sell White Ribbon Remedy for the Confirmed Inebriate alongside his alcoholic potions.

As he neared his tenth birthday, Eben Bradbury Jr. had a slightly longer walk to the Jackman School, and the pharmacy was another three blocks away. Eben and Lizzie left the house on Federal Street and moved into half of a large three-story house on Bromfield Street, just four houses away from Lizzie's parents and brother. Mary Todd continued to live on Middle Street, a ten-minute walk away. The year 1907 was marked by accident and illness for the family, beginning with a medical adventure for Marguerite, who tore her hand so badly on a piece of barbed wire that she had to be anesthetized with ether, a procedure that Eben, both concerned father and pseudo-medical man, noted in his diary with interest, bordering on enthusiasm. She healed quickly, but the next accident was not so easily repaired. Aunt Phebe, Mary Todd's boon companion, fell on March 8 on a stretch of ice, breaking her arm. Eighty-six-year-old Mary Todd herself was in failing health, complaining to her son of constipation, hemorrhoids and a host of other debilitating maladies. Lizzie and Eben took turns staying overnight with her when the pain and loneliness were overwhelming. By the end of the year, Eben hired a nurse to look after his mother but still visited her daily, their bond as strong as ever. In September, Eben Jr. pulled a wire hanging from the wall of their new house, a nine-

year-old's curiosity bettering his common sense. The wire was live, and his hands were badly burned. When Eben joined the U.S. Marines in 1917, the physical examination noted a scar on his thumb, a memento of that accident a decade before. It was a mark that would be used to identify his body in the field.

There was no hint of the trouble to come in 1907, however, and the family spent another idyllic summer together hopping trains and streetcars to the beach and taking long walks. They met friends at the midnight July Fourth bonfire at Joppa Flats, attended musical reviews and minstrel shows at city hall and enjoyed picnics, baseball games and fairs, punctuated by large family gatherings and celebrations. They held a tea for Mary Todd's birthday, had dinner with Lizzie's family down the street and played tennis and whist. Eben was physically fit, walking for miles with various configurations of his family, though as Eben Jr. grew, he increasingly became his father's traveling companion. The two Ebens walked together when the weather was fine, setting off clear across the city from Bromfield Street to the Chain Bridge and back and rambling through the cart paths of Old Town, gathering medicinal hepatica plants. The house at Bromfield Street had space for a large garden, and Eben lovingly tended his peas, corn and tomatoes, noting their growth alongside his notes on weather and fire. He was forty-six, healthy and modestly successful, increasingly invited to join the ranks of the powerful in Newburyport's elite institutions. Though his only trip to sea had been a vacation to Jamaica, Eben and his son frequently joined fishing trips and outings as honorary members of the Newburyport Marine Society, and in 1907, he was secretary of the Review Club, a rigorously intellectual book group headed by wealthy shipyard owner and antiquarian John James Currier. Not only did Eben hold his own among the masters of Newburyport's grand mansions and old families, he was accepted as one of them, even as he lived in his duplex with no household help and carefully noted every penny he spent in his pocket diary. Eben had also become a leader among his colleagues in the pharmacy trade, reuniting with his first boss, the venerable A.J. Atkinson, who had returned from New York, at the Massachusetts Pharmaceutical Conference that year and squiring visitors from around the state through Newburyport's finest establishments. Eben, Lizzie, Marguerite and Eben Jr. also made the rounds of Newburyport's cemeteries and burial grounds, paying respects to an increasing number of friends and relatives as the years went on. Bradbury relatives sometimes moved away, but they nearly always came back to spend eternity with their relatives in Old Hill or Oak

Hill or First Parish Burying Ground, and Eben faithfully arranged for headstones to be carved and plots weeded, sending proof of his efforts to far-off aunts and cousins.

In February 1908, Eben Jr. and Marguerite appeared in the Washington's birthday tableaux at Old South Church, Eben in a tri-corn hat and long coat as a companion of George Washington receiving the flag from Betsy Ross. Mary Todd was not there to see them. Since November of the previous year, she had been in constant pain and sometimes didn't recognize her son. On April 18, 1908, Mary Todd Bradbury died at 71 Middle Street, age eighty-seven, just two blocks away from the house where she was born. Her surviving sisters-in-law wrote immediately to Eben, offering sympathy for his loss. His aunt Frances wrote from Dexter, Maine: "Eben, you have been a good son and a great comfort to your mother. Now she is at rest from the trials and troubles of this world." There is no doubt that Eben, whose birth had seemed so providential in her middle age, was a good son, but she had also been a good mother, devoted to her only child. She was buried next to Captain Eben, who

Ebenezer and Mary Todd Bradbury headstones in Oak Hill Cemetery. *Private collection.*

she had waited for all those years ago and who had left her a widow for twenty years. One of her pallbearers was Lincoln Bradbury, son of Theoph and the father of young Albert, killed in the hunting accident just two years before, any coolness between the families of her husband and his brother long forgotten. The minister spoke of her "intelligence, patience, and quiet Christian life," and "many friends gathered to pay loving tribute to her memory." Eben visited his mother and father in Oak Hill Cemetery on the anniversary of her death and on her birthday for years to come.

Eben nearly lost his wife as well, just over two months later, when Lizzie stepped off a streetcar, dropped her coat and, while bending to pick it up, fell from the car and hit her head. She was going home from downtown, and Newburyport was so thoroughly served by public transportation that she had taken the car right home to Bromfield Street when the accident occurred. The newspaper headline read "Mrs. Eben Bradbury Met Accident Last Evening" and breathlessly reported on her "narrow escape," adding she was helped home by passersby before "medical aid was summoned." She recovered fully from the frightening event, and it does not seem to have dampened the family's enthusiasm for outings on the "electrics." That summer, they made their usual round of beaches, baseball games and fairs, and at the end of the year, just after his eleventh birthday, Eben Jr. was asked to give the Thanksgiving blessing at the Old South Church. Despite accident and injury and the loss of Mary Todd, the Bradbury family in 1908 had a great deal to be thankful for.

Chapter 12

AWAY FROM HOME

1910–1912

The next two years passed quickly, and as Marguerite and Eben approached adolescence, their father noted their increasing independence in his diary. Marguerite was often asked to attend concerts or outings with friends and spent summer nights on Plum Island. She was an accomplished pianist and singer, a favorite pupil of a Miss Ruth E. Titcomb, who featured her in recitals during these years. She joined Christian Endeavor, an evangelical youth group with a strong presence at the Old South Church, and became a devoted member of their social club and volunteer corps and the King's Daughters, a Christian charitable club that, among other missions, operated a rest home for working women of good reputation. Marguerite was strong-willed, a bit bossy, already sporting the small glasses and outsized hairdo that would become her signature look as a young woman. In 1910, after years of attending with her mother, she demanded that the Old Newbury Historical Society provide programs for young people and then volunteered to give one of the first lectures for its new junior members, on a topic that drew heavily on her own family's experience, "Newburyport Shipping Captains and Sea Tales." Marguerite graduated from the Jackman School on June 25, 1910. In the class photograph, taken just after the ceremony, she stands in the back row, near the teachers, with a slight smile, having just delivered the class prophecy, "which elicited no little amusement and surprise." The students had been together for eight years in a neighborhood that was extremely close, in a city where relationships were measured in generations. Marguerite

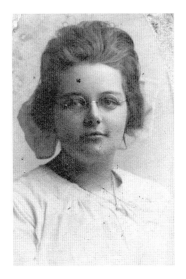

Marguerite Bradbury's Newburyport High School senior portrait. *Author's collection.*

knew her classmates well enough to spin a convincing tale of how they would all end up, a perfect assignment for a girl who was not shy about sharing her opinion. Though she could certainly be headstrong, she was also extremely generous and hardworking, and even as she became increasingly accomplished and independent, her father's diary offers evidence of a family that was still very close. Marguerite and her father attended concerts regularly, just the two of them, though she increasingly declined to join him on the long walks that were his chief hobby. She was solicitous of her parents, forging ahead and then apologizing and seeking their approval, trying to balance independence with her desire to please her parents and just a little thinly veiled jealousy of her brother. This dynamic continued well into adulthood, her duty to her parents becoming an excruciating weight during the cold, gray years when she became suddenly their only child.

Eben Jr. was quieter and more serious than his sister, but by 1910, he was also spending more time away from home and with friends. Unlike Marguerite, however, he relished the long hours walking with his father. The two of them enjoyed their time together immensely. Eben Jr., who had been playing baseball on the playground and in the old city's dirt lots, had begun to show some skill in pitching, and he went with his father to Boston to games played by the young American League and then followed these teams in the newspaper, discussing players and strategy as they walked. He still took music lessons and performed in tableaux and skits at the church, increasingly organized by his mother, who, with her sisters-in-law, had become one of the chief organizers of entertainments at the church. That summer, twelve-year-old Eben Jr. went away from home for the first time, to Camp Burley, a YMCA camp in Kingston, New Hampshire. Four days later, his father noted, "Lizzie and I rode the electrics to Pensler's Crossing and then walked three miles to Camp Burley. On the return we rode and found Rita had come home from Parker River." Marguerite had been staying with friends but had come home early, perhaps eager to have her

parents all to herself. Eben Jr. was gone for twelve days, his father joyously noting his return in his diary. Eben Jr.'s time at Camp Burley cultivated a competitive athletic streak, and even in his first year, he brought home three first-prize ribbons in sports, a record he would defend in future years. A week after his return, Eben took his son to meet Charles Elgins, a stoker on board the schooner *Georgia* who had served with Captain Eben. Eben Jr. was born a decade after the death of his grandfather, but his legacy loomed large in the family, and the young man was excited to meet someone who had sailed with him. He began to take a greater interest in the history of his family, joining his father and sometimes his mother as they visited family graves. Together they walked through the leafy solitude of Oak Hill, past the centuries-old crooked stones of Old Hill and even across the river to the old Salisbury Burying Ground, where his father told him the story of Mary Perkins Bradbury, his seventh-great-grandmother, convicted of witchcraft. They laid flowers at her grave.

In July 1911, thirteen-year-old Eben Jr. went off once again to defend his ribbons at Camp Burley, earning four firsts and three seconds and the Camp Burley "B" for exceptional sportsmanship and good behavior. The next month, Marguerite went away with the King's Daughters to Gordon's Rest in East Hanson, a former private estate that had been converted into a rest home for reputable working women, who paid for their board on a sliding scale. Marguerite enjoyed the work but was clearly worried that the Ebens might be having too much fun without her. "Dear Papa," she wrote, "I suppose you and Eben are waltzing around since it is Sunday afternoon." She wrote with a bit of pique, "Please write at least once before we leave," adding, "I suppose you and Eben have been having a delightful time" while assuring him that "I haven't been homesick at all." Eben Jr. and his father were having a delightful time, of course, though thirteen-year-old Eben was also spending more time with his friends from the neighborhood.

Shortly after Eben Jr. began his final year at the Jackman School, he and his pals went down to one of their favorite haunts. The Boston and Maine switching yard was a fun place to walk to after school. The yard was dotted with stacks of railroad ties and empty cars and locomotives, places to hide out and chat or get out of the weather. One of these explorers, an adventurous boy named Frank Johnson, who had grown up across the street from Eben's old house on Federal Street and was one of his closest friends, jumped from the empty boxcar in which the boys were hanging out just as the shifter engine went by. The boy was caught and

Eben Bradbury Jr.'s sports ribbons from Camp Burley. *Author's collection.*

thrown some distance as the engine screeched to a stop. It is not difficult to imagine the shouts of the crew, the cries of the boys who had just seen their friend hit and the awful silence that followed. The crew carried Frank to one of the sheds of the Perkins Lumber Company next door. He was barely conscious and was brought to Anna Jaques Hospital, where he was rushed into emergency surgery and died of internal hemorrhage. Once again, Eben Jr. shared the grief of the city at the sudden death of a young man, "bright and loveable and full of promise," but this loss must have felt like nothing else in his young life. The ties connecting Eben

Jr. to Frank Johnson's family outlived him, and three years later, Eben helped to throw a party for Frank's older sister, Elizabeth, a classmate of Marguerite's and now a close friend of his as well. They were part of a tightknit group of Jackman School friends, and the loss of Frank brought them even closer together.

NEWBURYPORT HIGH

1912–1916

The following summer was marked by another loss, this one his maternal grandmother, Lucy Chase Bayley. Eben had noted the symptoms of something like a stroke two years earlier, and "Mother Bayley's" obituary noted that she had been ill for quite a while, so her death was not a surprise. It was a sad time but meant that "Father Bayley," now a sprightly seventy-seven-year-old widower, was more of a presence in the lives of his grandchildren. He is often listed in Eben's diary as a dinner guest and joined his daughter's friends and family at cards. By the fall of 1912, Eben and his sister were once again in school together, this time at Newburyport High School. In her two years there, Marguerite had made her mark, joining the rhetorical club, performing in small theatricals and playing piano and selling popcorn and candy at school events. Eben was eager to try out for high school sports, but in one of the first football practices of his high school career, he fractured his collarbone and was sidelined until the spring. He was small for football, but fast, in the top three in his grade in track and field. Eben Jr. was also a competitive bowler, a high scorer at "Boston Pins" on the Twomey Colts team of the North End Boat Club. In the spring of 1913, he tried out for the high school baseball team and secured a place as junior pitcher, also playing shortstop with the neighborhood team, the Joppa Redskins. His academic performance was strong as well, though his sister was the star student, and a popular one, too. She was one of the few sophomores invited to the senior dance in 1912.

NHS fair ribbon from Eben Jr.'s second senior year. *Author's collection.*

Eben's years at Newburyport High School were happy ones, even in the shadow of his big sister. He had a large group of friends, most of them from Jackman School days; an exceptionally close relationship with his father, with whom he still walked for miles every week; and all the amusements of a small but vibrant city with the beach just a mile away. He was popular, appearing on the guest lists of the many sixteenth-birthday parties thrown for classmates all over the city in 1914, and he had a great many female friends, though none of them seem to have received particular romantic attentions.

In June 1914, Marguerite graduated from the college course at Newburyport High School in a class of eighty. Her father kept the program from the graduation exercises, with her penciled notations of her classmates' destinations written next to their names. As always, Marguerite knew exactly where she was going. In March, she had received a letter from Colby College in Waterville, Maine, offering her a place in its program, a scholarship of thirty dollars for her freshman year and a job for an additional one dollar per week. She would be the first woman in her family to attend college, and it would be a financial stretch for her family to send her, but Marguerite was determined. Just four days after Marguerite's graduation, the Austro-Hungarian Archduke Franz Ferdinand was assassinated in Sarajevo. Like most of the good people of Newburyport, Marguerite and her brother paid scant attention to developments overseas. During the summer of 1914, as Germany invaded Belgium and frantic diplomatic maneuvering failed to halt the steady, grinding march toward world war, Eben Jr. went back to Camp Burley for the summer session, accompanied by so many Newburyport boys that the camp had its own biweekly column in the local newspaper, with Eben Jr. appearing regularly as a top scorer on one of the two camp baseball teams, the "Almost-as-Goods." He was back home by July 28, in time to score the winning run for the South End summer team. Marguerite, in the meantime, spent the summer selling books door-to-door for the Uplift Publishing Company, her energy and enthusiasm engaged in the service of her substantial tuition bill.

In the fall of 1914, Eben Jr. entered his junior year at Newburyport High School and Marguerite hopped a train to Waterville, Maine, where she was to spend the next four years constantly worried about money and wondering why her parents didn't pay more attention to her. A collection of promissory notes in her name attest to how difficult it was for the family to float her tuition, and she worked and paid off as much as she could with her own efforts, while prodding her father for more support. Eben Jr. spent the winter as the star bowler for the Newbury Grange team, his score hovering just under three hundred in most games. He held the record for the best three-string score for his team. In February 1915, he was elected president of the junior class, though he resigned a week later. Someone had made Eben an offer he couldn't refuse, and he would leave his lifelong friends and classmates behind in the fall of 1915, but for the remainder of the school year, he devoted all of his energy to bowling, playing three or four times per week. As war spread across Europe, Newburyport was in the throes of a bona fide bowling craze, with teams from every factory and boat club hosting tournaments weekly and the scores filling whole pages of the newspapers. Throughout 1915, Eben Jr. was playing so well that he elicited editorial comment, noting when he slipped into a "hot contest" with another bowler for a title. He is also called "Bunny" as often as Eben in the paper, his diminutive stature earning him a nickname that stuck. Despite his height, he was also a track star whose favorite event was, ironically, the standing high jump, and of course he played baseball whenever he could.

The year began with the death of Aunt Phebe Todd, who had been Mary Todd's dear friend and companion, her bright, quick spirit a foil to Mary's tendency to melancholy. She was the last of her generation and had gone to live in Portland, Maine, with her son. Like all the others, she was shipped back to Newburyport to be buried, with Eben making her final arrangements. Hers was one more family grave to visit on Memorial Day and birthday anniversaries, but increasingly, Eben was making his walks without his son. It is not clear who or what set Eben Jr. on the path to Kimball Union Academy (KUA) in Meriden, New Hampshire, but it seems likely that an offer had been made as early as February and that the arrangements were made with the help of "Doc," one of the organizers of Camp Burley. Eben's diary of 1915 notes his comings and goings, but father and son rarely walked together anymore. Lizzie stepped up as her son pulled away, joining her husband to gather herbs in Old Town and on longer rambles to Amesbury and Salisbury by way of the Chain Bridge. After one more summer season swimming and playing baseball at Camp

Burley, Eben Jr. left Newburyport to spend his senior year at KUA on September 15, 1916, and his sister returned to Colby a week later. For the first time in nearly twenty years, Eben and Lizzie were alone in the house.

On September 23, Eben Jr. wrote home, the first letter in his own hand that survives. His handwriting is clear and sharp, sloped to the right, and he addressed the letter, as he would all subsequent mail, "Dear Folks." Money was tight, as always, and like Marguerite, he wanted his parents to know that he had been careful with every penny. "I have been washing dishes after supper," he said. "I have not spent much yet." The senior class was taking its fall trip, a car tour and then a hike into the White Mountains, and he wrote to let his father know that there might be a fee for that, but he was hoping that previous years' class dues would cover it. Eben appears to have written to his son at school twice a week, much as his own mother had written to him at pharmacy school. By the beginning of October, a little homesickness was creeping into Eben Jr.'s letters from KUA. "I miss the salt air very much," he wrote. "I have been counting the days until I will be home again." He had been very frugal but needed just a little money for clothes. He wrote, "Tell Ma that my old suit pants have worn out in the seat." He had ten weeks left in the term, a long time to be away. He also kept up a regular correspondence with Marguerite, with whom he shared an increasingly strong bond. They were both scrambling for money, far away from home and working hard to get good grades and make their parents proud. Meanwhile, back in Newburyport, after the sinking of the *Lusitania* by a German submarine in May, the city was slowly taking more notice of world events, and Eben Bradbury began to sell Red Cross stamps in his pharmacy. It is the first indication, in his diary or his letters, that he took any real notice of the war.

Chapter 14

TWO SENIOR YEARS

1916–1917

During his winter break, Eben bowled once again for the Newbury Grange team and went back to school feeling much better, with his grades holding up and graduation from a prestigious private school just months away. On March 3, he was thinking about baseball season and assuring his parents that he was studying hard and "getting along fine now." He just needed four dollars for baseball shoes, quickly, as "the snow is slowly disappearing and soon we will practice outdoors." He had a great tryout with the coach, and the rumor around the school was that he would be selected as the primary pitcher, a task that he felt completely equal to: "My arm is feeling fine and as I have put on weight I should be able to get more speed than ever." He closed with one more reminder that all would be for naught if the money for shoes didn't arrive, "so send the money soon, please!" The money arrived, shoes were procured and Eben Jr. was "much obliged." He was impressed with the more adventurous boys at school, several of whom had snowshoed up Mount Ascutney in ten feet of snow and were "very tired by the looks of it this morning," but though he was feeling fine in March, his heath, never reliably robust, failed just as baseball season picked up at the end of April, and he came down with scarlet fever. He wrote, exasperated, "I got out of the 'pest house' this morning, and I feel fine." He was behind in his studies and had missed practice, and his parents were being oppressive. "I am all well, so stop worrying about me," he said, and a few days later, he wrote to assure them that he was, indeed, fully recovered and "having a good time as usual." He was fully engaged in all the senior shenanigans, despite

joining the class in its final year—stealing the class tree from the juniors and enjoying his "senior privileges." He was also getting ready to pitch his first game. As it happened, he had been one of many who had come down with scarlet fever that season, so the game against Lebanon, the official start of the season, had been delayed long enough for him to play. As usual, the letter was also a plea for money. Senior pictures were being done, and with graduation only four weeks away, Eben Jr. needed a new suit. "I have only one nickel left," he complained, "which won't last me a great while." While Eben had sent along money for baseball supplies, he failed to send a check for senior pictures, necessitating an additional letter a week later. Eben Jr. was a little irritated at the oversight and very unhappy with the performance of his baseball team in its first outing. "Our team couldn't seem to hit the ball, but we certainly made lots of errors," he complained. "I started in pitching but lasted only seven innings." They lost 7–3. In better news, he had won a costume contest, with a pound of chocolates as the prize, dressed as a Turk in a teacher's borrowed suit. He closed with a few more requests for money, including a doctor's bill from his time in the "pest house."

Sometime between May 3 and May 10, 1916, Eben moved his family from the half house at 51 Bromfield Street to a large, long house at 67 Bromfield, next door to Lizzie's father and brother Harry and his family. The house was a "temple-front" Greek Revival with massive two-story pillars and a heavy front pediment. It was a house to be reckoned with, a big step up from the half houses Eben and Lizzie had previously chosen for their family. It was an interesting choice at a time when most other couples would be downsizing. A month later, on June 15, Eben Bradbury Jr. graduated from Kimball Union Academy. Marguerite had received an invitation but was not able to attend, though she wrote to her father that her college friends had swooned over his senior picture: "They all think I have a very good-looking brother." The commencement speeches were an interesting mix of local ("The Potato Growing Industry"), social ("Women in Higher Education") and national ("Preparedness—The National Issue"). It was this last topic that captured Eben Jr.'s attention and reflected the mounting conviction that the United States needed to prepare for war.

The United States had tried desperately to remain neutral in the conflict abroad, but by the spring of 1916, Germany's aggressive attacks on neutral vessels, which had already killed hundreds of American citizens by 1916, and its harsh treatment of civilians abroad had begun to turn public opinion away from strict neutrality. Most American citizens, while hoping to avoid going to war, were now in favor of preparing to fight. Newburyport men

were already in the fight, having joined Canadian, French or British forces in the field, or offering support services through the ambulance or aviation auxiliaries. Eben Jr. showed no sign of wishing to be a soldier, however. He stayed in Meriden for a week after graduation, collecting his things and saying goodbye to his classmates and teachers before catching a train in Lebanon, New Hampshire, and heading back to the family's new house at 67 Bromfield.

Eight days later, he served as an usher at the graduation ceremony of his old Newburyport High classmates and resumed his place on the South End baseball team. Marguerite came home as well but joined friends at a rented cottage on Plum Island for the majority of the summer. With no particular plans in place for the upcoming year and no employment on the horizon, Eben Jr. signed up at Newburyport High School for a postgraduate year. In 1916, this was not unusual, and the school was glad to welcome back a good student with a strong athletic record. If he was preparing for college, it was a good move, as deficits in coursework could be rectified or additional higher-level classes taken. It may also be the case that Eben Jr. was simply a bit lost and not quite ready to leave the nest. Perhaps he had returned home from KUA hoping, in vain, that some line of employment would open up. Whatever his reasons, Eben Jr. threw himself back into school, or at least school sports, with a vengeance, and since it was the fall, he joined the football team. He wrote to Charles "Bart" Bartholemi, a classmate one year behind him at KUA and a football player, for advice, and Bart responded, "Don't get killed, that's my advice. I feel like I get killed every night! Sometimes I get the breath knocked out of me." Bart revealed that at KUA, Eben Jr. had traded in his Newburyport nickname, "Bunny," for a somewhat more mature "Brad." Bart assured him that he was missed in Meriden, New Hampshire, particularly by the girls, "who are prettier than ever." By November, Eben Jr. was still playing football but was also bowling again for his Newbury Grange team and held its season record for highest-scoring three games once again.

Kimball Union Academy senior week and graduation program from 1916. *Kimball Union Academy.*

On December 1, page four of the *Newburyport Daily News* carried Eben's bowling scores;

the news of his football team's ignominious 13–6 defeat by Amesbury in the annual Thanksgiving game; a letter about Roswell Sanders, a Newburyport man who had been injured in France in the ambulance service; and a column called "Outline of War News." At the close of 1916, it was impossible to ignore the news from abroad, and Americans were less likely to wish to do so in any case. The National Defense Act, passed just before Eben Jr.'s graduation and the likely spur to the preparedness speech, had acknowledged the likelihood of war, expanding and restructuring the U.S. Army and National Guard and establishing ROTC, the Reserve Officer Training Corps, to prepare high school and college students for service. The government worked hard to drum up support for mobilization, thinly veiled as defense, and newspaper articles were a critical link in preparing the American people for war. As more local men and women joined the effort, news from the front had far more local interest and so appeared in more detail, which encouraged more local people to join, which produced more stories, etc. At the end of the 1916 season, Eben Jr. was presented with his varsity letter for football, joining his letter in baseball from KUA and letters in baseball and track from Newburyport. On a cold Christmas Eve 1916, Eben Jr. walked the length of the city with a group of classmates and friends, stopping to sing carols at the jail, the home for the aged and on street corners. The caroling ended at the top of Bromfield Street, and Eben Jr. said goodnight to his friends and walked down to his house, where his parents, his sister, his grandfather and his aunt and uncle were returning from church. It was the last Christmas they would ever spend together.

Eben Jr. spent the early months of 1917 bowling, studying and contemplating his future. In March, he won second prize and ten dollars in an essay contest at the historical society, the same prize Marguerite had won two years earlier. His essay, on William Wheelwright, a Newburyport merchant and philanthropist, was published in its entirety in the newspaper, its flowery language and patriotic themes as much a product of their time as of the young man who wrote them. Still, it is hard not to look for a sign of the monumental decision Eben was about to make in his description of "our great and glorious country" and his admiration for Wheelwright's tenacity and love of adventure. On March 28, anticipating entry into war, Newburyport mayor Walter Hopkinson formed a local public safety committee to organize the city for mobilization. On March 30, the mayor delivered a message to the city council: "Events of the immediate past must convince all Americans that war with Germany is inevitable." These events included the release of the Zimmerman Telegram, in which Germany

made overtures toward an alliance with Mexico that included returning some disputed American territory, and Germany's resumption of submarine attacks on neutral vessels. The Committee on Public Safety planned a patriotic rally and march on April 9. Eben marked the date in his diary, noting that it was "on a large scale" and "a great success." By the time three thousand Newburyporters turned out to march, the nation was at war. On April 6, after five days of earnest debate, Congress had declared war on Germany and its allies. Marguerite wrote breathlessly from Colby that day, wondering what would happen now that they were officially at war. "Talk about excitement!" she said. There had been a terrorism scare in Maine, with two sticks of dynamite thrown onto the train tracks, and college boys were being called up to join their national guard units. She was afraid the school would close if too many of the boys went off to fight. "P.S.—Is there any excitement there in Newburyport?" she asked. That night, the fire horn blew signal 444, ordering active-duty navy men back to their ships. Three days later, Newburyport turned out in support of the war in all of its multicultural splendor. Clubs and fraternal organizations dating to the American Revolution joined Polish, Armenian, Greek, Italian, Jewish and French marchers; Boy Scouts; and Civil War veterans. Firetrucks wailed and factories blew their whistles, and the streets were aflutter with flags and bunting. It was a very festive start to an ugly, bloody war.

Chapter 15

FIRST TO FIGHT

APRIL–JULY 1917

If Eben had planned to join the armed forces if war was declared, he certainly kept it to himself. If Marguerite had any inkling that her brother was about to join the fight, she would have struck a different tone in her letter of April 6. It seems more likely that Eben was as caught up in patriotic fervor as anyone else. He was young, fairly healthy and very competitive. He also had no plans, and his postgraduate year was coming to an end. There is no evidence that Eben Jr. was pursuing college or training courses, and the war came along at a time when he was a bit at a loose end, eager for adventure but unsure of his next step. Once he had decided to fight, Eben wanted to get abroad as quickly as possible, and the marines, with their determination to be "first to fight," were a natural choice, honoring his family's naval history while fighting on the ground. For a generation that had not known war, the thought of being in France in a matter of months, facing off against the Hun, an exaggerated caricature of the German soldier, was intoxicating. On Saturday, April 14, Eben took the train into Boston to the marine recruitment office and underwent a preliminary examination. That night, he was back home in tie and tails as assistant head usher in the senior play, *Bachelor Hall*. The next day, he received word that he was to report to Boston on Monday, April 16. Before he left for the train that would take him away from his city forever, Eben Bradbury Jr. was asked to say a few words to his fellow students. The newspaper reported that Eben told them that he "would do his duty, and hoped that other members of the senior class would join him to uphold

the honor of the country." The paper lamented his loss to the upcoming baseball season and to his school. "Bunny, as he was known to his fellow students, is a popular member of the class," it read. He had actually been a popular member of two senior classes at Newburyport High School.

That blue-sky afternoon, a hastily assembled party made its way to the train station with Eben Jr. and his family, Mayor Hopkinson, several city councilors, a small band and dozens of friends. At the station, the mayor wished him Godspeed and shook his hand. If his father, his friend and companion on a hundred rambling walks, had a private moment with his only son as they stood on the platform, it remains between them, but it is not hard to imagine the mixture of pride and dread that Lizzie and Eben felt as the train pulled away, the crowd cheering and waving its flags. If he had been homesick just a year before in New Hampshire, the fear that this might be the last time he saw his city, his family and his friends must have come over Eben Jr. in waves. He watched the low wooden buildings, the church steeples, his own Old South Church visible from the platform, brick factories, smokestacks churning, recede in the distance and finally pass from sight. In his diary, Eben simply noted, "Left this afternoon for Boston to join the U.S. Marine Corps."

The next morning, April 17, Eben left Boston for the marine recruit depot in the Philadelphia Navy Yard, where marine companies were being hastily organized. Eben wrote to his parents almost immediately. He gave them his address at the navy yard and asked them, and anyone from home, to write but wasn't sure how long he would be there. "I'll be one of the first to get out of here," he said proudly. He had been assigned to Company A, "the first and only company organized and the only one to receive our uniforms." Eben Jr. had taken and passed another physical examination and had sworn his oath, and it was a Saturday night, so he was hoping to go out on the town in his fresh new uniform. Drill began on Monday. Eben and the other marine recruits were living in tents, and assembling, pitching and cleaning these tents kept them busy. Eben Jr. was reasonably sanguine. The food was plain but plentiful, and the other guys he met seemed all right, "but of course there are a few bums." Two days later, Eben dashed off a hasty postcard, asking for his shaving kit. "Hurry," he said. "We are required to have one." Four days after that, he asked for handkerchiefs and money. "Am short now," he said. "I get paid $5 and it will have to last me a month." Ten days after he left Boston, he finally got his package with his shaving kit and handkerchiefs and a little money. His father was worried that he didn't have enough underwear and offered to send him

Eben Bradbury Jr.'s medical examination record from his marine corps entrance examination, April 1917. *Author's collection.*

some from home. Eben Jr. assured him that it was part of his allowance and described his clothes in the kind of detail that was meant to soothe an anxious parent. He had not only underwear but also six pairs of good socks, he said, and two warm army blankets. "You see it's not such a bad assortment after all." He was exhausted from drilling, and his feet were sore, but "I will get used to it in time, I suppose." He was one of about 500 recruits, "besides the 1200 regulars in barracks." At the end of the month, he wrote to Mr. Wells, the Newburyport High School principal, urging other Newburyport lads to enlist in the marines and assuring them that he "was well and enjoying the work." Meanwhile, back in Newburyport, Eben Jr.'s last bowling scores were published; he was second in the league. His parents walked together to the cemeteries and Devil's Basin in Old Town, and Marguerite brought home a classmate who had never seen the ocean, much to Eben and Lizzie's amusement.

On May 5, Eben Jr. wrote home to thank "Pa" once again for sending a package and some money. He was feeling a little homesick but was also beginning to show a touch of the bravado that came with spending weeks with veteran marines. He didn't think much of the militia, the citizen

soldiers who had been recently called up to drill in Newburyport. "They are no good for active service," he said. His parents had sent him a list of all the people he might know in Philadelphia, trying to connect their son with home. He hadn't seen anyone from home but reminded them that if he did run into Lieutenant Moody, an old friend of the family, "I can only salute him and keep my mouth shut." He had received vaccinations and was inoculated against typhoid, and he was feeling pretty bad. The vaccinations had produced a rash that had spread under his arms, and he was swollen and sore but brushed it off: "A little pain does no harm once in a while." The tent city in which marine recruits were held was cold and damp, and every chance he got he went walking, a pleasure he shared with his father. He had been allowed to leave the camp the previous Saturday, but rather than frequent public establishments with his new compatriots, he started off alone to explore the city. He walked all night and into Sunday, forty miles in his estimation, and was unimpressed. "I saw what there was of Philadelphia, anyway. I don't think much of the place, believe me."

By May 13, Eben Jr. wrote to his parents to ask them to change his address. He was no longer a recruit but part of a proper company, and though he was still in training, the distinction was important to him. His Company A was drilling and training hard, as it was the goal of Major General Commandant of the Marine Corps George Barnett to have the experienced marines recalled from other stations and the recruits ready to join them as soon as President Wilson requested their services. The marines were in transition in 1917, with some in government and military leadership looking to disband them entirely or attach them to the army, questioning why the navy needed a land force. The declaration of war with Germany was an opportunity to demonstrate the value of having a force prepared to hit the ground almost immediately. Newly minted marines were being rammed through training as quickly as possible, with the assumption that more experience could be gained once they were on the ground in France. Eben Jr. was eager to get to the rifle range in Maryland for training and nervous about his performance. Like his father as a young man, he had trouble with his eyes that was sometimes debilitating but had not yet flared up that year. He was hungry ("would accept anything to eat too"), a little lonely and missed his family, but he was still having a reasonably good time. Even in hard training, exhausted and footsore, Eben Jr. found a place to play baseball, heading to Fairmount Park with some friends: "It seems good to enjoy ourselves

playing once in a while." He thought it would be three or four weeks until they were able to do rifle training. On May 22, he was just recovering from a week of severe tonsillitis but found that his voice, always a little thin, was suddenly robust and husky. He was happy that this symptom of his trouble would be slow to disappear. He was irritated that he had been ordered to sit out the long hikes in full gear enjoyed by his fellow marines, "like an old invalid," but once he recovered enough to join them, he realized that his 35-pound pack "weighs about 150 pounds" after marching even for a short time. He was still eager to get done with training and out on active duty, believing with a certain naïveté that "it will be easier for us then." Eben Jr. hopped aboard a British cruiser in the navy yard with some other young men and found them "a happy bunch," relieved that the United States was in the war and sure it would be over soon. He had finally moved from the dreaded, soggy tents into proper barracks and loved it, but he was already hoping for a furlough back home to Newburyport in the summer.

As fate would have it, President Wilson made his request for men on the ground, General Burnett answered and Eben Jr. and his fellow trainees were rushed off to Winthrop, Maryland, to complete their rifle training just four days later in preparation for shipment to France. Eben Jr. did not do well, scoring only 122 out of a possible 300 points. It was a very poor showing, and he blamed a new rifle, though it made no difference. Despite his failing score, after four days of practice, he was back in Philadelphia, writing to his "Pa" about the rumors that were spreading like wildfire through camp. "It started with one of our corporals telling another that he would be willing to bet half a year's pay that Company A wouldn't stay in Philadelphia for more than two more days." He thought maybe he would be going to Haiti or Santo Domingo and would write when he knew more.

This letter was postmarked June 1, 1917, and then Eben Jr. was gone. The day he wrote this last letter from the United States, marine companies began flooding into the Philadelphia Navy Yard from Cuba, Pensacola, Norfolk, Haiti and the Dominican Republic. On June 3, Eben Jr. was assigned to the Fifty-Fifth Company, which had just returned from service in Cuba, a scrappy, two-hundred-man company that had a solid core of experienced marines, 34 percent. The Philadelphia Navy Yard was a hive of activity, but the men were not told exactly where they were going or when. On June 8, the Fifth Regiment, to which the Fifty-Fifth Company was assigned, began to leave, and Eben Jr. was on the *Hancock*, the first ship out. The *Hancock* went first to New York, where the troops were transferred

to the newer and faster ship *Henderson* on June 14. As the *Henderson* steamed toward France and war, the marines trained and drilled, cleaned their guns and equipment and were assigned duty stations on the ship. On June 27, Eben Bradbury Jr. saw France for the first time as his ship pulled into port at St. Nazaire in Brittany. That same day, the Fifth Marine Regiment was attached to the First Division of the United States Army, and all troops were ashore and in camp southeast of the city by July 3.

Chapter 16

THE LAST LETTER

JULY 1917–FEBRUARY 1918

On July 4, back in Newburyport, Eben reported to his diary that it was "a fair day, but a very quiet one." In France, the camp was teeming with activity and, as it turned out, with germs. Soon after his arrival in France, Eben began to feel ill. On July 12, he was hospitalized with a severe case of pneumonia in both lungs. It had been nearly six weeks since he had been able to send a letter home, and now, dangerously ill, he was in no condition to write. In Newburyport, his parents, who didn't even know that he had been sent overseas, began to panic. On July 18, Eben wrote to the commander of the marine barracks at the Philadelphia Navy Yard, asking for any information about his son. The marine adjutant who responded said that mail "should reach" Eben Jr.'s new general address in New York, if marked with the correct regiment and company numbers, but confirmed to his parents that he was "serving outside the United States." Eben kept sending letters and waiting for a reply, and as the days continued to pass with no answer, he grew increasingly desperate. On August 5, he wrote to A.P. Gardner, who represented the Massachusetts Sixth District in Congress. His secretary, W.W. Lufkin, was "glad to render what assistance I can in the matter of locating the present whereabouts of your son." The Marine Corps, which had been less than responsive to Eben's requests, replied immediately, and defensively, to Lufkin. They confirmed that Eben Jr. was indeed in France and stated that there was "no reason why Mr. Bradbury should not have heard from his son, as there is absolutely no restriction placed on letter writing by enlisted men, and the Post Office Department is doing all in its

power to ensure the prompt delivery of mail….As far as is known, Private Bradbury is in good health and serving with his company. Any serious illness or injury would of course be reported immediately by radio or cable." The envelope also contained a brochure on the correct way to send mail to a marine. This letter is remarkable, not necessarily for its content, which was likely repeated in hundreds of replies to worried loved ones, but for its author. Eben Bradbury had made enough noise to get the attention of the most powerful man in the United States Marine Corps at a time when he had a whole lot of other matters to attend to. The letter was written by General Barnett, commander of the Marine Corps himself. And he was, of course,

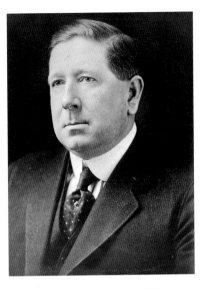

Massachusetts congressman W.W. Lufkin, who tried to locate Eben Bradbury Jr. twice and failed on both accounts. *Library of Congress.*

totally wrong. Eben Bradbury Jr. was not in fine health and serving with his unit but lying, deathly ill, in a base hospital in France.

Still, Eben was reassured, noting in his diary that Eben was reported to be well. He wrote a note of thanks to Lufkin for his efforts, who graciously replied that it was "a great pleasure to render you this small service" and offered to be at his service again in the future. It was not the last time Eben and Lufkin would take on the slipshod recordkeeping of the United States Marine Corps together.

Finally, on September 8, Eben Jr. was feeling up to writing from his hospital bed "Somewhere in France." "I am still recuperating….I guess I am getting stronger every day," he said, "but my eyes trouble me not a little….I guess it means me wearing glasses for good." His handwriting had changed and was larger and looser than before, additional evidence of deteriorating eyesight. He had met some "fine fellows" in the hospital and made plans to visit them all after the war. "I guess I will have a lot of good times after I get home." He was hoping for peace and did not seem particularly anxious to see action. The reality of war as seen in a base hospital and a long illness had dampened his bravado. He closed, "With love and best wishes, your affectionate son." This letter must have been received with nearly rapturous

Base Hospital 59 at Rimaucourt, Haute-Marne sector, 1918. *Private collection.*

joy when it finally made its way to 67 Bromfield Street on October 10, and when another letter arrived the next day, written on September 18, at last Eben and Lizzie could breathe a little easier. In this letter, written to assure his parents that he "was still living, etc.," Eben Jr. was clearly frustrated and anxious about the continuing pain in his eyes. "My eyes are what is bothering me the most. They don't seem to get better." Two days later, weak, nearly blind and having failed basic marksmanship, Eben Jr. was on his way back to his Fifty-Fifth Company, now stationed in Bourmont on the Marne River and attached to the United States Army Second Division. He had missed bayonet training, poison gas drills, small arms range practice and artillery/infantry exercises, all extremely valuable to his ability to survive.

In October, Eben Jr. was catching up, but in November, he was sick again, still weak from pneumonia and also suffering from the after-effects of the rheumatic fever he had contracted in the hospital. This was most likely the cause of the pain in his eyes, as rheumatic fever, on rare occasions, causes lesions and ulceration in the eye. He was not sick enough to be hospitalized, however, and for the next three months, he was listed in the muster rolls as

This letter arrived in Newburyport on October 10, 1917, after a long period of silence in which Eben Bradbury Jr. was feared dead. *Author's collection.*

"sick but present"—healthy enough to remain upright during roll call. In a November 11 letter, despite his questionable health, he was surprisingly upbeat, declaring himself "well and contented." He had received a package from his parents and one from Marguerite and was thrilled to have American tobacco and gum. The Newburyport Library had sent him magazines, and he was very grateful to them as well: "Please find a way of thanking them for me because I don't know who to write to." He was trying to save money and exchanging letters with childhood friends from Newburyport who were also in the armed services, including Henry Donlon, who had been the paperboy down the street from Eben's pharmacy. He was feeling bad that he hadn't written to his sister, whose graduation from Colby College in June he hoped to be home to attend, but promised to write to her that day.

Eben Jr.'s Fifth Marines was drilling with the newly arrived Sixth Marines in November and December, which must have given him a chance to catch up on some of the training he had missed, and in January and February, larger-scale brigade maneuvers, including exercises with French troops, gave the commanders of the marines a chance to see what their men could do. On February 2, Eben Jr. had a moment to write for the first time in two months. Once again, he was most grateful for cigarettes and candy but also

so happy for news from home. He had received letters from his "Grandpa," William H. Bayley, and promised to write to him but had just been "so busy." It had been a cold, snowy winter, and he was grateful for a few temperate days: "You remember I used to argue the good points of winter against those of summer, but I guess I have changed my opinion on the subject." He closed with love, promising to write again soon.

Two days later, Marguerite wrote to her father from college, enclosing a newspaper clipping from the *Boston Traveler*, showing General Pershing visiting a marine camp in France. She thought that a young man in the foreground of the image, with his hat pulled down low, could be her brother, "but it is too blurred to be sure." It was close enough that Eben sent it on to his son, asking if it was him. "Believe me, am I glad to hear from you," he answered, but "the picture you enclosed was not mine." He returned the clipping, which had now passed through the hands of all the members of the family. He was feeling good. The weather was warming up, and though there was mud everywhere, it was drying quickly "under the warm rays of the sun." It was so cold in Newburyport that the Merrimack River had frozen nearly all the way across. Eben Jr. remembered how it had looked in other winters, when he and his father had walked along the waterfront to see if there was ice on the piers. One of his father's friends had died, and he was sorry to hear it. "You were very chummy," he said. "You must miss his noise very much." He was getting mail regularly and feeling "as lively and fit as ever, but waiting patiently for the summer." The summer would never come. Eben's last words to his parents, his sister and all of the Newburyport friends he had known since they were born was a simple and haunting, "Remember me to all. Love to everyone." Eben Jr. was headed to the front.

The closing lines of the last letter written by Eben Bradbury Jr. to his "folks." *Author's collection.*

Chapter 17

TO THE FRONT

MARCH–JUNE 1918

By March 17, 1918, Eben's Fifty-Fifth Company was in the trenches outside Verdun, the scene of terrible carnage earlier in the war but by then considered a "quiet sector." Still, service in the trenches was frightening and deadly, and the inexperienced troops faced German lines directly. Eager young marines who tried to pick off the enemy were quickly dispatched by veteran German snipers, and Eben Jr. experienced enemy artillery barrages for the first time. The marines occupied both frontline and reserve trenches, and it was on April 19 and 20, during one of the transitions, when exhausted front-liners were moving back and reserves were coming up, that Eben Jr.'s company was attacked, and he experienced his first close combat with the enemy. It was heartening that the marines fought well and the Germans retreated quickly, and army leadership took notice. By mid-May, the Fifth Marines had left the front lines and moved to a training camp outside Paris, where they were preparing for what the Allies hoped would be the next and final stage of the war—open space warfare—as the Germans were finally driven from their trenches and fortified positions and pushed out of France. The official record of this training described it as a pleasurable time for the men after months in the trenches: "The surroundings were beautiful, the weather enjoyable, liberty available, and spirits high." The German army, of course, had no intention of being driven out and by May 30 had punched through the French army lines and was closing in on Paris, knowing that if the capital could be occupied, the war could be won, or at least concluded on very favorable terms, before the Americans could fight in any significant

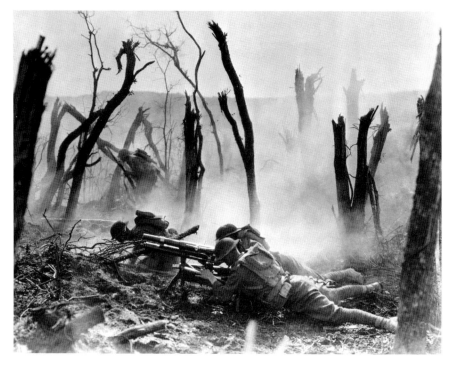

Marine machine gunners in Belleau Wood. *National Archives.*

numbers. After a long, drawn-out war of attrition, suddenly there was action—desperate, bloody action—and Eben Bradbury Jr. was about to be right in the middle of it.

Eben Jr. and the Fifth Marines were up and ready to go at dawn on May 31. They had a hot breakfast and boarded trucks driven by French colonial troops. The drive toward the front was difficult, the roads outside Paris choked with civilians fleeing from the German onslaught and exhausted French troops. One of Eben Jr.'s fellow marines described the journey: "All afternoon we met a continuous stream of civilians flocking to the rear in all sorts of conveyances. Many walking and leading dogs, goats, cows, horses. Some wheeling baby carriages loaded with a few choice articles they saved. Such a scene I never saw before and hope never will happen again." The French army was now in general retreat and falling back toward Paris, visibly dejected and defeated, and as the marines marched in the opposite direction, one French officer ordered them to join the retreat. Marine captain Lloyd Williams shot back, "Retreat, hell, we just got here!"

On June 2, the Fifth Marines had reached the outskirts of the town of Château-Thierry, an idyllic, rolling landscape of wheat fields and thatched farmhouses whose residents had fled so quickly that they had left tools in the fields and animals loose. The marines, on the other hand, had advanced so quickly that they had outpaced their kitchens and so were living off emergency rations and what they could scrounge up from deserted farms. Corporal Henry Fletcher Davidson, a fellow marine, noted on June 3 that he had been able to find "twelve rabbits, five hens, and a goat. Also a bag of beans and some eggs." They were under heavy fire from German artillery and machine guns: "Marines advanced all afternoon with considerable losses. Steady stream of wounded brought into 1st aid station in Lucy." The marines formed a defensive line along the road to Paris, determined to stop the German advance at any cost. The French general in command, Jean Degoutte, had little confidence in the American troops, untested as yet in this war. The Second Division chief of staff assured him, "General, these are American regulars. In one hundred and fifty years, they have never been beaten. They will hold."

As the French retreated, the German army tried to pursue them to Paris, attacking the American defenders over and over again, but as promised, they held. Despite sporadic attacks on the line, the German drive toward Paris was halted, and they established defensive positions to the west of Château-Thierry, in the area around the Bois de Belleau (Belleau Wood to the Americans). Belleau Wood was true to its name, an idyllic aristocratic hunting preserve. Despite its proximity to the front, Belleau Wood was largely untouched, a densely wooded old-growth forest with gulleys, ravines, rocky outcroppings and narrow paths, ideal for nurturing the game animals that wealthy Parisians were fond of hunting—and also perfectly suited for defensive positions. The woods were surrounded by wheat fields, still young in the early days of June. Advancing troops could be easily seen from well-hidden positions in the woods.

As the Germans occupied and fortified their positions in and around the woods and the American troops shored up their lines and brought up artillery and supplies, the line quieted somewhat on June 4 and 5. During these days, both sides found clues of who and what lay ahead. The Germans found a dead marine on June 4 and now knew that they were fighting American and not just French forces. The Americans found a German machine gun company attempting to set up a defensive perimeter in the fields outside Belleau and drove them off after a fierce fight. Still, Eben Jr.'s commanding officers believed that Belleau Wood was lightly

defended, as aerial reconnaissance was unable to see the German position in the dense undergrowth, and French intelligence grossly underestimated the number of German troops on the ground. The Germans, on the other hand, had a much better understanding of the number and placement of American troops and were ready for them when they came. On June 5, the order to take Belleau Wood came through. The battle would begin before dawn the next day.

Chapter 18

BELLEAU WOOD

JUNE 6–JUNE 12, 1918

American artillery began firing just before 4:00 a.m. on June 6, and in the general confusion that accompanied troop formation, the marines were ordered to advance in compact waves rather than small teams that could infiltrate the German lines more easily. As the sun rose, turning the sky blood-red, Eben Jr. and his fellow marines shed their heavy packs and moved out across the young wheat fields, most carrying only weapons, ammunition and gas masks. Their first objective was the high ground known as Hill 142. Fifty yards into their advance, German machine guns opened up on the men, who were close together and completely exposed. As the men fell to the ground, desperately scraping for any cover, snipers in trees along the border of the woods opened fire as well, picking them off as they crawled. Several marine officers, realizing that they would all be killed unless they reached some cover, stood up, rallied their men and made mad dashes for the woods. The marines who made it to the woods were forced into bloody hand-to-hand combat as they tried to knock out the machine gun nests that were hidden in the rocks and brush. In the afternoon, surviving marines regrouped and prepared for an attack into the forest itself, but the Germans also had time to reinforce their lines: "Wave upon wave of Marines walked out of the shadows of the cool woods into hell." German commanders couldn't believe their eyes. One described the marines walking methodically toward his position, in "thick lines of skirmishers, supported by columns following immediately behind. The Germans could not have desired better targets." Facing another march into an open wheat field, officers rallied their

World War I: The Fight of the U.S. Marines in Belleau Wood. From the painting by the French artist Georges Scott. This appeared in a 1921 issue of *Collier's Magazine. Private collection.*

men forward as best they could. In a line that would become legendary in marine corps history, Gunnery Sergeant Dan Daly, a veteran marine who had served in Santo Domingo, Haiti, Peking and Vera Cruz, called out, "Come on, you sons of bitches, do you want to live forever?" The German machine guns waited until most of the men were out in the open and then mowed them down. The wheat fields were quickly strewn with the dead and the dying as the remaining men broke formation, regrouped and ran toward any cover they could find. As the afternoon turned into night, the Germans gassed the woods as well, compounding the terrible suffering of the wounded.

As that bloody day finally came to an end, the gains made by the marines were significant. They had captured Hill 142 and held the southern end of Belleau Wood and most of the small village of Bouresches. The price they had paid was terrible, however. The marines lost more men on June 6, 1918, than on any other day in their history—31 officers and 1,056 men—but Eben Bradbury Jr. was still alive. The decimated marines spent the night trying to straighten their lines and close gaps to avoid a German attack from behind or the side. Communication, never stellar, was extremely confused, as runners risked their lives to try to bring messages to units on the move. Eben Jr. and the Fifty-Fifth Company spent the night trying to figure out who was alive, where the Germans were firing from and where they were all supposed to go next. Men held onto each other in the darkness, came under fire, became disoriented, lost their companions and were shot alone in the dark. Marine platoons fired on each other. Sometime during the night, Eben Jr.'s company lost its leader, Captain John Blanchfield, as it tried to move back from the main body of the woods to straighten their lines. Eben Jr. would have been exhausted, terrified, his eyesight, already damaged, nearly useless through the thick lenses of his gas mask. As the sun came

up, young army lieutenant Elliot Cooke was in command of the Fifty-Fifth Company. Eben Jr. and the rest of the Fifty-Fifth Company were ordered to straighten out a section of the line by taking a small patch of woods with a reported eighteen German machine gun nests, firing continuously on the marines. Around 5:00 p.m., they set off through another open field, Cooke noting vignettes of death—a marine officer who died with his pants down, a headless German soldier darning socks, marine bodies in a perfect sunburst around a shell hole. Lieutenant Cooke was an army officer, not a marine, and suddenly in command of unfamiliar men in the midst of a terrible day: "Night was coming on and there I was with a company of men I didn't know anything about and who didn't know anything about me. We were out of touch with all friendly troops and the United States of America was three thousand miles away. I all but burst out crying." He did his best to organize the men so they could hold their patch of woods, and with Cooke and the other men of his company, Eben Jr. fended off marauding German soldiers and ducked whistling bullets in the darkness and survived a second night.

In Newburyport, as across the country, news of developments in France had been vague. General guidelines for the press dictated that for the sake of security and morale, individual army units could not be identified with a specific action. The furious fighting at Belleau Wood was different, however. It was led by the marines, which could be identified as a group, and since there were relatively few of them—only about fourteen thousand in France in June 1918—Eben and Lizzie would have known when they read about the fighting in Belleau Wood that they were reading about their son. The June 7 *Newburyport Daily News* headline identified the marines specifically for the first time, with a page-four story headlined "American Marines Drive Back Foe." The story described "reports of violence" and "hard fighting" but gave no indication of the terrible cost of checking the German advance. General Pershing had no interest in letting the Germans—or the folks back home, for that matter—know how many of his marines were dead. Eben still wrote long letters to his son every Sunday and sometimes sent an additional letter during the week. There had been no reply since March.

June 8 dawned with Eben Jr. and the Fifty-Fifth Marines still holding their small patch of woods. They were hungry, thirsty, dirty and exhausted, some slightly injured and others covered with the drying blood of the wounded whom they had managed to drag from the field during the night. Those who had died in the forward positions closest to German guns had to be left in the open for now, their bodies swelling and rotting in the heat. Facing the nearly impossible task of rooting German machine gun nests from the dense forests,

the decision was made to destroy the trees in a massive artillery barrage on June 9. Now, added to the staccato machine gun fire and crack of rifles was the earth-shaking, ceaseless pounding of heavy guns as the idyllic hunting grounds of the aristocracy was turned into a twisted wasteland of splintered, shattered trees. By just after 7:00 a.m., a company commander reported that "artillery has blown the Bois de Belleau to mincemeat." This was not entirely true, as the ruins of the woods still provided plenty of cover for machine guns. It is difficult to follow Eben Jr.'s exact movement through that hellish, stinking, burning wasteland that day, but the Fifty-Fifth Company had no rest. They were shelled constantly, so exhausted that some slept right through artillery barrages. There was no significant ground gained between June 6 and 9, but now the reputation and future of the marine corps itself seemed to hang on the outcome of the fight for this small piece of France. Newspapers across the world were praising the "saviors of Paris," and the men themselves seemed determined to prove that they could hold their ground. Eben Jr.'s battalion commander was amazed at the tenacity of his marines: "As soon as a company of infantry took over their part of the front, what was left of one of my companies came out. Their eyes were red around the rims, bloodshot, burnt out. They were grimed with earth. Their cartridge belts were almost empty. They were damned near exhausted. Past physical limits. Traveling on their naked nerve. But every one of them was cocky...full of fight." With the entire world convinced that the marines had taken Belleau Wood and saved Paris, it now had to be taken at any cost.

On June 10, the marines attacked north into the shattered woods, but despite an artillery barrage that should have knocked out German guns, they were driven back under withering fire. One marine described flattening himself to the ground as bullets flew like hot nails above his head. The Germans were also using mustard gas all along the line, adding to the confusion and disorientation of the men. Eben Jr.'s company made small incursions from the west and then hunkered down to spend the night. At 4:00 a.m. on June 11, Eben Jr. followed the Fifty-First Company behind a rolling barrage of American and French artillery. The ground was damp, and a thick fog hung in the air. The smoke from the shells blew back toward them, and the German machine guns, once again left mostly intact, opened up on the men. Battalion commander Major Fredrick Wise, disoriented and overconfident, led his men in the wrong direction, heading southeast rather than northeast. To make matters worse, he refused to believe his officers, who reported the error after a few hours, so all of the intelligence about the area—of which there was precious little to begin with—was useless.

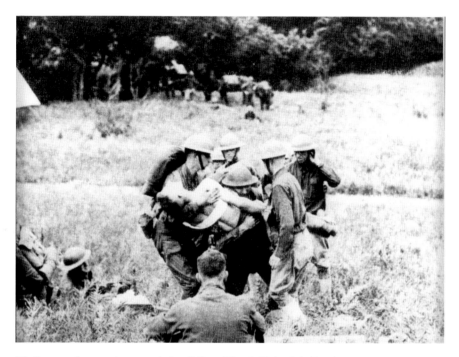

Medics carrying out the wounded at Belleau Wood. *National Archives.*

Believing that he had reached his objective, Wise reported that the Fifth Marines had cleared the wood and then realized he was wrong but was hesitant to report the truth, costing precious hours when his battalion was dangerously exposed.

By June 11, Eben Jr.'s Fifty-Fifth Company, headed by Elliot Cooke, was down to eighty men from its previous two hundred. The Fifty-First, which had led the Fifty-Fifth that morning, was down to sixteen. Lieutenant Cooke was aware of the disorganization of the battalion and began to move his men and other companies whose commanders had been killed or wounded into defensive positions. When a group of marines arrived from another company and asked Cooke where the front was located, he pointed north, south, east and west. Wise, who had realized that he was lost and had no idea of the extent of his casualties, finally began sending messages asking for assistance, but the message that he had taken Belleau Wood had already been passed up the line. Lieutenant Cooke, Eben Jr. and the remains of the shattered companies of the second battalion spent the night fighting German patrols and wondering where they were and which direction they would be headed in the morning.

On the morning of June 12, Wise had roughly determined his position and had a plan to make good on his boast that he had cleared Belleau Wood. Another artillery barrage would roll ahead of them into the northeastern side of the wood. This time, the Fifty-Fifth Marines would lead the advance. The early hours of the day must have been an agony of anticipation and fear, as Eben Jr. and his fellow marines prepared for the advance while German artillery steadily pounded their position. The American artillery began shelling, targeting just past where they thought the Second Battalion would be. Because of the confusion the previous day, they were way off, shelling far north of the German lines. Wise noted nervously that the barrage seemed light and asked that it be extended. In the smoke and sudden quiet, Eben Jr. stood waiting and talking with his friend Corporal Karl McCune. Lieutenant Cooke blew the whistle, and they said goodbye and good luck and moved out with the company into the open field facing the German line. In their six days' experience at Belleau Wood, the marines had learned to avoid walking slowly in formation into machine gun fire and advanced instead in small, staggered groups. Eben Jr. was pinned down in the field for about two hours as machine guns, snipers and grenades blasted his companions. Knowing that the only way forward was to make a run for the German positions and knock out the machine guns, Cooke stood up in the field, called his men and began to run. As guns blazed, the marines ran toward the edge of the woods, yelling and cursing and desperate. They crashed through the first German line and surged toward the back line, fighting with bayonets and fists and rifle butts. The Germans broke and fled back to the north. When Lieutenant Cooke gathered what was left of his Fifty-Fifth Company to pursue the retreating Germans, Eben Bradbury Jr. was not with them. He was running, shouting, excited, the hunger and exhaustion he had felt for days temporarily pushed from his mind by the sheer terror of the moment, when he was caught by machine gun bullets, pitched back, fell and never moved again.

IMMEDIATE REPORT OF CASUALTY

JUNE 12–SEPTEMBER 29, 1918

E ben Jr. was killed just short of the woods, and there he lay until the whole area was finally cleared on June 26. He was first buried in the field, his grave marked with a plain white cross on which his helmet was slung. According to the instructions for the burial of battlefield casualties, "Chaplains of the division are charged with all other details except the actual burying. They collect personal belongings, hold whatever services are possible and in conjunction with the Graves Registration Service, assure proper identification." Eben Jr.'s body was identified, his meager effects collected and then his casualty card and all of his personal belongings disappeared. Details of what happened next are spotty, but it seems that he was reburied soon after outside the town of Lucy, in U.S. Cemetery 1764, a plot of land designated to receive the dead of Belleau Wood and other conflicts in the area. Once again, the report of his death was taken and reported to the Fifth Marines, and an official file card was typed up.

On June 13, 1918, the day after her brother's death, Marguerite was at Colby College, frantically busy as always, graduation week beginning. She needed money, of course, and wrote to ask her father for another five dollars. "Dad, I'm sorry to beg for money all the time…" she said. Marguerite had stepped up her letters home to her parents, knowing they were no longer hearing from Eben Jr. She never asked for news of him, knowing that if there was anything to tell, they would have passed that on. She chatted about going to the movies, seeing friends, how strange it was to be at school when most of the boys had left to join the war. She

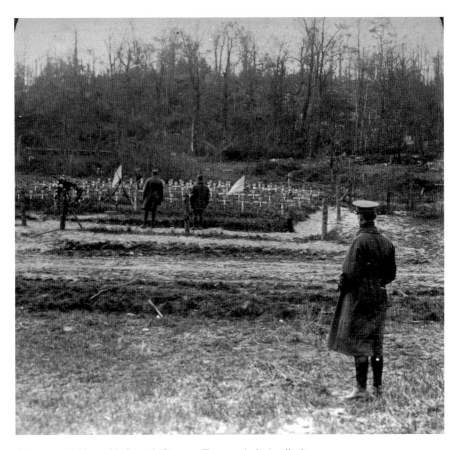

Cemetery 1764 outside Lucy le Bocage, France. *Author's collection.*

came home more often than she ever had before and asked her mother to visit in Maine. She had her senior pictures taken, a mortar board perched atop her round face. She reminded her parents about commencement repeatedly, hoping they had not forgotten, hoping that even as distracted and worried as they were, she would be appreciated for her hard work, for the extraordinary achievement of being the first woman in her family with a college degree. She sent them newspaper clippings of train schedules and brought friends home to meet them.

Eben continued to hope for the best, writing long, chatty letters to his son, returning again to familiar themes like weather and baseball and the adventures of friends from Eben Jr.'s Jackman School days. He knew Eben must be homesick and described everyday life in Newburyport as best he could. On May 13, when his son was in the trenches outside Verdun, Eben

Above: Immediate report of casualty. Note the date of death and the date sent. *Author's collection.*

Left: Marguerite Bradbury's senior profile from Colby College, 1918. *Private collection.*

reminded him that it was Mother's Day, and he should probably send his mother a note: "We are looking for a letter each day." The following week's letter closed, "It has been seven weeks since we heard from you." "We are still looking for that letter that hasn't arrived," he said at the end of the month. On June 3, just days before Belleau Wood, Eben wrote to his son, his joy raw and palatable: "A postal arrived from you last Thursday, and was very welcome! We would like to hear from you oftener, but of course you understand that and will write as often as you can." If he wasn't writing because he had a hard time finding paper, Eben would send him as much as he could ever need from the shop. He was also feeling a bit sentimental; June 6 was his twenty-fifth wedding anniversary, though "circumstances are not favorable" for a party. He was worried that Lizzie hadn't yet received her Mother's Day letter and gave his son another gentle prod, hoping he was well and "everything is alright."

A letter arrived from Eben Jr. to his sister on June 14, two days after his death, but likely written months earlier. The timing was perfect, as she was just about to graduate, and the arrival of news from their son and brother, even if terribly out-of-date, put them all at ease for at least a few days. In his last letter to his son, written nearly a month after his death on July 9, 1918, Eben was still cheered and comforted by the relatively recent arrival of that letter, enough that he went on at some length with paternal concern for Marguerite's future, as she had graduated but job offers seemed very low and she hadn't yet decided what to do with herself. That was followed by family news, real estate transactions, updates on other young men in the service from Newburyport and, finally, a request for more information about his son's whereabouts: "I saw in the paper that the soldiers in France in the rear of the front were allowed to tell where they were. If you are allowed to inform us of your location, we should be very glad to have you do so. Write as often as you can. With love and good luck wishes from us all, Pa."

By the end of July, Eben was choked with worry once again. There had been no letter since June, and that was months old, and he was desperate for assurance that his son was still alive and well. People in town had been asking about him as well, and rumors began to circulate that he was missing and perhaps injured or dead. Eben went first to Newburyport mayor Hopkinson, who had shaken Eben Jr.'s hand at the train station. There was little he could do, so he kicked the request up to the state congressman who represented Newburyport, Carl C. Emery. Emery had his secretary send a letter to their congressman in Washington, D.C., who was none other than the efficient and solicitous W.W. Lufkin. He had assumed the seat of his former boss when

A.P. Gardner died suddenly in January 1918. Lufkin was familiar with both Eben Bradburys, having demanded information from the marines regarding the younger at the request of the elder just one year before. Lufkin promised to help again and assured Representative Emery that he would be in touch with the War Department immediately. On August 8, Lufkin telephoned Emery and read a telegram just received from the War Department. "The Marine Corps have no record of any casualty to Eben Bradbury Jr.," it read. He then folded up the telegram itself and sent it on to Emery, asking him to share it with the Bradbury family.

The following day, the newspaper carried on its front page the news of the battlefield death of eighteen-year-old Private John Henry. He had been killed on July 19, and his parents had received the telegram that informed them of their son's death on August 8—nearly three weeks later. John Henry was a friend of Eben Jr.'s, one year younger but captain of the football team that Eben Jr. had joined during his second senior year. He was also a Camp Burley boy and had grown up on Lime Street, just one block away from the Federal Street house where Eben had lived most of his life. The article closed, "Private Henry was the first Newburyport boy fighting with American troops to be killed in action in France."

The next day, Mayor Hopkinson contacted the newspaper to let his city know that their fears about Eben Jr. were unfounded. "No Basis for the Rumors," it read. "There is absolutely no record of any casualty to Eben Bradbury Jr. of this city. Bradbury is now serving in France." At some point that summer, the city of Newburyport designed its city service medal, which would be presented to local servicemen when they arrived back home. Eben Jr.'s medal could now be ordered with confidence, and it was cast and set aside to wait for his return. Eben Bradbury Jr. had been dead for over a month when John Henry, the "first Newburyport boy," was killed. He had been dead for two months, and buried twice, when the telegram was sent assuring everyone that he was fine. One month later, on September 9, 1918, the "immediate casualty" card that reported Eben Jr.'s death was sent by runner to marine headquarters, marked "prev. reported." Something had gone horribly wrong. Eben and Lizzie were put off for a few weeks by the official report, but when another month went by with still no word from their son, Eben called his high school friend John Hardy, now an attorney in Boston, who contacted the Soldiers' Information Bureau. On September 25, he wrote to Eben, letting him know that an official request for information had been cabled to Paris but that it would be another two weeks to two months before he had a definitive answer.

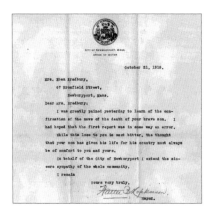

Newburyport's Mayor Hopkinson, who had accompanied Eben Jr. and his family to the train station the year before, sent this letter after the arrival of the official telegram on October 19, 1918. *Author's collection.*

After months of searching and agonizing worry, the answer they had been looking for arrived at 67 Bromfield Street in a tragically ordinary way. One of Eben's own letters to his son was returned in the mail, marked "Killed in Action, June 12, 1918," in the last week of September. It had been, as Eleanor Little would confirm from the Paris post office, "all over France." Elliot Cooke had seen each letter, signed it, stamped it and sent it on, and there were other marks where other hands had made small changes and then sent it away. There was no dreaded telegram, no uniformed officer marching soberly up the front steps—just a returned letter, his own letter, with scribbled notations, a small stamp and the world ending suddenly, there in the kitchen. It must have been unbelievable, breathtaking and then a gut-punch agony. The marines had said he was alive just a month before. They were to have weeks more while the bureau investigated. There must have been some mistake. Eben did not keep a diary in 1918, or it has disappeared. There is no way to know how he suffered in the first days after he learned of his son's death in such an unexpected way. Over the next month, the wound was opened again and again as the letters sent from 67 Bromfield in May, June and July trickled back home. News spread quickly. The *Newburyport Daily News* and the *Boston Herald* carried the story on September 29, and condolence letters poured in, some from the same people who had pressed the War Department for information and received false assurances. On October 19, 1918, the dreaded telegram, signed by Charles Long, assistant commandant of the marine corps, and delivered by a uniformed officer to the pillared porch of the Bradbury house finally arrived: "We deeply regret to inform you…"

Chapter 20

THE AFTERMATH

1918–1974

Marguerite secured a position in a small girls' school in Warner, New Hampshire. The influenza epidemic was in full swing, and it was healthier up there than in Newburyport, so even after hearing the devastating news, her parents wanted her to stay away. On October 7, she wrote an eight-page letter home, describing her meals, her classes, her companions and, perhaps most poignantly, her walks. She never mentioned her brother, which would seem oddly heartless, but she understood that her parents' grief was such that it could not withstand articulation. Bunny Bradbury, light of his parents' life, boon companion and walking buddy to his father, would be put to rest in one last letter, and then they would never, ever speak directly of him again.

On November 10, 1918, Eben wrote to Marguerite in New Hampshire. Corporal Grant of the Fifth Regiment had paid him a visit. Though Grant was in the Fifty-First Company and not the Fifty-Fifth, he had come to know Eben Jr. well and wanted to offer his family his condolences and give them as much information about their son as he could. Eben made careful notes during the conversation and sent them along to Marguerite. He had sent her a map called the "Western Battle Front," and he described how to find the places (four inches from the left corner, etc.) where Eben had landed, trained and fought. Grant had been injured on June 6, that first terrible day of Belleau Wood. He had no information about Eben's death and had seen and talked to him for the last time on May 26.

Since Eben was talking about his son and the pain was already acute, he kept going. Reports of an armistice had come in the previous week, resulting

in Lizzie "getting quite stirred up." The Old South Church where Eben Jr. had spent so much of his young life was dedicating a service flag to him and had asked Lizzie and Eben if they would attend. "Of course I could not go alone very well, and mother knew she could not stand it." He hoped Marguerite was well and sent his love.

The next day, November 11, one day before his son's birthday, Eben stayed home with Lizzie and a now-bedridden Grandpa Bayley as the city went wild in celebration of the real Armistice. The war was over. On November 29, Mayor Hopkinson asked Eben for a picture of his son and a description of his service so he could hang it on the Gold Star wall in city hall, and Eben tried his best to keep up with the mountain of paperwork requested from the War Department. He filled out insurance forms, received Eben Jr.'s posthumous medals and asked again and again what had happened to his son's personal effects and why his death had not been reported. He received no answer.

In January 1919, the Department of the Navy sent Eben a letter stating that the report of Eben Jr.'s death "has not as yet been received." In February, the Red Cross informed him of the number and location of Eben Jr.'s grave, followed by a lengthy form letter from the Graves Registration Office in France titled "Information for the Friends of Our Dead," including a caution that information about individual graves would not be available for months. At some point, Eben stopped answering official letters about his son.

Marguerite, for her part, had met a young man, William "Billie" Lampley from Hickman, California, who was serving in the Portsmouth, New Hampshire Navy Yard. She first mentioned him in a letter in February 1919, and in June there was a flurry of requests, demands, conciliations and apologies from Marguerite as she tried to plan a wedding while managing her grieving, distracted parents. On July 16, they were married in the front room of 67 Bromfield Street, the article in the newspaper noting that "they will live in California." Marguerite left for married life in Hickman just after the wedding, and Grandpa Bayley, the venerable Newburyport Marine Society secretary and historian, died on December 2, 1919. Eben and Lizzie were more alone than they had ever been before. Eben still sporadically sent letters asking for information about his son. One such letter, returned and then kept, reveals a father increasingly frustrated with the treatment he had received. He repeated all the information he had gleaned from other sources, adding, "We have received nothing more, neither have we ever received any personal effects he may have had."

Beginning on December 8, 1919, the United States War Department began sending notices to 67 Bromfield Street requesting information about the "disposition of remains." A form was to be filled out if Eben Jr.'s body was to be exhumed and sent home for burial. When Eben and Lizzie did not answer this form, or the two others that followed, the requests became increasingly shrill. Finally, Eben wrote, identified his relationship (Father), added his name and answered "no." (punctuation is his) to the question of whether the remains should be brought back. The *American Legion Weekly*, widely distributed among veterans of the recent war, carried a listing in its "Find Your Buddy" column asking for "any information concerning death" of Eben Jr. James Dickens, a classmate and friend of Eben Jr.'s, had joined Eben's father in the search for answers.

On March 4, 1921, Eben noted in his diary, "Eben Bradbury Lampley born at 10:24 p.m. at Hickman, California." Marguerite had remembered her brother and father in her firstborn son, though the birth of another baby boy named Eben must have been bittersweet. Though they had managed to avoid any of the myriad church, school, camp and social events in honor of their son, Eben and Lizzie felt compelled to attend the dedication, on July 4, 1921, of a giant boulder with affixed tablet, placed in the newly named Eben Bradbury Triangle at the corner of the Bartlett Mall, whose paths, pond and fountain were a favorite leisure walk for the good people of Newburyport. Eben and Lizzie rode in the procession and sat in the hot sun listening to Mayor Hopkinson sing the praises of the "young sons of Newburyport. So brave. So patriotic. Their souls…have joined the ranks of the immortal."

Two years later, Eben noted in his diary, "sold my store to Frank Hoyt." The pharmacy on the corner of State and Pleasant Streets had been Eben's private kingdom for forty-five years, since he was just out of high school. He had worked and saved, hawked potions, gathered herbs, sold tickets to hundreds of plays at the high school and city hall. He had scraped, painted and cleaned. The walk from Bromfield Street all the way down Prospect, over Federal, out to State Street and down was as familiar as his own face. He knew everyone, knew more about them than almost anyone. He knew who had hemorrhoids and troubling flatulence, whose breastmilk hadn't come in, who might be pregnant. His son had walked with him to work a hundred times, had stopped to pick up a paper or eat a handful of peanuts. The letters that he sent to France were mailed from the post office right down the street. The store represented the weight of the past, in a city whose memory stretched back generations, centuries, back past Eben Jr. playing in his backyard and bowling at the Grange, to a whale ship captain, a

84378-25B-1-HES

February 9,1920.

Sir:

Under date of December 8,1919,this office sent you forms
with the request that you fill same and return them to this
office at once,so that your wishes in regard to the disposition
of the remains of your son,the late Private Eben Bradbury,Jr.
Marine Corps,may be placed on file in this office for proper
action.However our records fail to show that you have returned
these forms or have acknowledged their receipt.

Above: Letter regarding the "disposition of remains," sent on February 9, 1919. *Author's collection.*

Right: "Find your buddy" listing from *American Legion Weekly*, April 9, 1920. *Public domain.*

American Legion Post No. 88, Camp Custer, Mich.

Co. D, 103D ENG.—Anyone with Pvt. Michael Edward Howard at time of death, July, 1918, please write his mother, Mrs. Elizabeth Howard, 300 Lawrence St., Lawrence, Mass.

DAVE WILLIAMS—Formerly Utah National Guard. Any information regarding this man write his sister, Mrs. Elizabeth James, 69 King Row, Park City, Utah.

MICHAEL KOTUN—Believed to have served in Army. Anyone knowing his whereabouts communicate with Dept. of Civilian Relief, American Red Cross, 44 East 23d St., New York City.

FRED DALY, formerly Pvt. Co. C, S. A. T. C., Indianapolis, Ind.—Information concerning his whereabouts desired by his mother, Mrs. W. Daly, 1228 S. Cherry St., Janesville, Wis.

13TH FLD. ART.—Pvt. James J. Reed, reported by C. O. as wounded, and by War Dept. as killed. Information desired by his father, J. W. Reed, R. F. D. No. 3, Emporium, Pa.

55TH Co., 5TH MARINES—Pvt. Eben Bradbury, Jr. Any information concerning death communicate to James Dickens, Jr., care of Wolfe Tavern, Newburyport, Mass.

Co. B, 18TH INF.—Information regarding death of Pvt. Martin J. Nygard, last heard of Sept. 29, 1918, desired by his father, B. M. Nygard, Hendricks, Minn., Box 45.

HARRY W. WALLING, formerly U. S. Navy—His mother has not heard from him since March, 1917. Write Mrs. H. W. Walling, 38 Bristol St., Springfield, Mass.

Co. M, 312TH INF.—Frank Novak. Anyone knowing details of his death write Adj., Leon Heath Post No. 51, Pine City, Minn. Information desired for his relatives.

Co. F, 16TH INF.—Pvt. Joseph Swamberg, reported killed in action Oct. 4, 1918. Information concerning his death desired by his mother,

silversmith, a witch. He had become the caretaker of the dead in a very real way; relatives across the world relied on him to see to their loved ones buried in Oak Hill and Old Hill in rambling family plots. His devoted mother was there; the grumpy aunts; kind uncle John Merrill, who had bought him a pony when he was a boy. He had visited them, tended their graves, had their stones carved. They had once been an anchor, a comfort. With Eben Jr.'s death, it had all begun to seem meaningless. He had stopped visiting the cemeteries. Eben and Lizzie gathered the things they could not bear to leave behind—his grandfather's silver spoons, their son's ribbons from Camp Burley, his father's ships' logs, photographs, portraits and letters. They sold their furniture, packed steamer trunks with whatever could fit and boarded a train for California. When the Massachusetts Commission on the World War wrote to Eben to ask for information for a report they were publishing in August 1924, they were already gone.

Eben and Lizzie moved into an apartment in Modesto, California, within an easy drive of Hickman and Marguerite. Sixty-three-year-old Eben walked all over his new city. Eben and Lizzie both babysat their expanding collection of grandchildren. Little Eben Lampley was joined in 1924 by Donald and in 1926 by Marjorie. Eben, now retired, kept his diary in detail, his weather and wind reports strangely out of sync in a city far from the sea. He went down to see the trains arrive with his grandson and taught him to swim in the canals. The whole family went camping in the redwood forest. He and Lizzie played cards with the extended Lampley family, went to the movies together and walked for miles through the city. Eben turned seventy in 1931, and two months later, his only granddaughter, Marjorie Byrd Lampley, was hit by a drunk driver as she played in the front yard with her brother Donald. She was rushed to the hospital, unconscious. Donald suffered a severe head injury, and Marjorie never regained consciousness, dying early in the morning of August 11. When Marguerite proved to be too paralyzed with grief to care for Donald, Eben moved him into their apartment in Modesto, dressed his wounds, made him special foods and doted on him. Eben was, at heart, a gentle, nurturing man, and it must have been satisfying for him to tend to an injured boy when his own beloved son had been so far beyond his help in his hour of need. Marjorie's killer was tried for murder, convicted of assault and sentenced to two years in jail. Eben and Lizzie attended every day of the trial. Eben visited Marjorie's grave almost daily, bringing her flowers, noting every anniversary of her passing, her birthday, the date of her killer's trial, in his diary. There was still never any mention of his son, as significant birthdays, war remembrances, the first, then fifth, then tenth

anniversary of his death passed. In 1930, the United States government began the Gold Star Mothers program, bringing the mothers of battlefield casualties buried abroad to visit the graves of their children. Eligible women were notified in the newspaper, and on February 23, 1930, in the *Fresno Bee*, Mrs. Eben Bradley [*sic*], mother of Eben Bradbury Jr., was invited to take a trip to France, to the Aisne-Marne cemetery on the outskirts of Lucy le Bocage, all expenses paid. The listing ran again and again, corrected her name, ran again. In a column next to the invitee, their answer was registered. Lizzie never responded, not even to decline the offer.

Elizabeth Chase Bayley Bradbury, the enigmatic L.C.B. and E.C.B. of Eben's youth, Mrs. B and Mother, but always Lizzie, died in Modesto on December 15, 1932. Eben remained in Modesto, living alone but cared for by Marguerite and the Lampley family, until his death on February 16, 1941, with the country on the brink of another world war. When his apartment was cleared out, his trunk full of all of his Newburyport things, his letters and ships' logs and coin silver spoons, was taken to Hickman, where it remained until Marguerite's death in 1974. It seems that around this time, the letters and some papers were separated from Eben's diaries and the other objects and artifacts that Eben had hauled to California, and it all began a mysterious journey around California that would eventually lead it all back to Newburyport, and to me.

Chapter 21

YOU WILL TAKE IT TO HIM

2015–2017

I am a manager of historic houses for a preservation organization and a local historian and writer, primarily of magazine articles, the occasional newspaper column. I also occasionally write AP history textbook chapters for some extra money. My family has lived in Newbury since 1635, our family names woven through the same registers and burying grounds as Bradburys, Chases and Bayleys. I have been fascinated with the Great War since I was a child, since my early, nerdy days alone with C.S. Lewis and J.R.R. Tolkien and Robert Graves.

I first met Eben Bradbury Jr. on a gloomy Sunday in February 2015. An academic publisher had recently announced a World War I project based on first-person documents, and I eagerly signed up for sixteen chapters. On this particular Sunday, I was researching and writing about the Battle of Belleau Wood using General Pershing's post-battle report, along with several letters and first-person accounts of the battle. The letters were particularly hard going. They described scenes like this one, recorded in a letter from Private Harvey Pottinger to his mother: "The first sight that struck my eyes when our little platoon started through the Woods was a place where the Germans had shot liquid fire and the ground and woods all around were scorched black. In the middle of this were men's bodies all charred and some of their faces almost burned off. A little farther on, I stumbled over the body of a man who must have been killed a month before. I tell you such scenes as that gives you a sick feeling. I have seen nothing like it before." Another letter describes the German machine gun fire as "red-hot nails

Eben Bradbury Jr. memorial stone in Newburyport, dedicated July 4, 1921. *Cynthia August Images.*

flying all around." Elizabeth Ashe, a nurse with the American Ambulance Service, remembered the first night of the battle, as marine casualties were brought into her field hospital: "The Marines fill the place to overflowing. The hospital increased from 600 to 1500 beds overnight. The medical staff was overwhelmed....I looked at the stump of a young Marine whose leg had been amputated and said: 'Now, my boy, aren't you sorry you didn't stick to your drum?'" One of my sources was a series of letters and diary entries written by Corporal Howard Fletcher Davidson, an electrician from Bovina, New York, who joined the marines on the first day of war and served as a runner just behind the battle lines at Belleau Wood. He literally ran back and forth with messages, food and supplies, from one group of marines to another. I liked Howard, whom his friends called "Fletch." He was funny, warning one of his friends that he didn't want to find himself "patting your face with a shovel" and noting that he was going into camp to have his clothes "de-cootie-ized." He was sweet, mourning the death of a cow and her calf that had been tagging along with his Eighty-First Company. He was also extremely brave, describing an artillery attack that left him clawing at the ground for cover and finding himself face-to-face with the skull of a soldier hastily buried in the months before.

After hours of reading and writing this strenuous stuff, my eyes were burning and my neck ached, and I decided to take a break and run an errand at the drugstore around the corner from my house. On my way to CVS, a trip I have made hundreds of times, two important things happened. First, I absentmindedly missed my turn and had to turn into the far side of a triangle that led back to CVS. Second, I looked to my right as I waited at the stop sign. There, next to my car, was a boulder with a green plaque on it, reading: "Eben Bradbury Jr. Triangle, named in honor of Eben Bradbury Jr., 55th Company, 5th U.S. Marines, who was killed in the Battle of Belleau Wood(s), France, June 12, 1918." I felt a physical reaction to this, one of those moments where you are reminded that death, history and grief are all around you all the time in a place like Newburyport. I'm used to this in my work. I'm always bumping into people who know dead people that I know, and we talk about them like they were college roommates. This felt different somehow—academic history textbook work rarely connects me to my neighbors. I took a deep breath, did my shopping, came home and called my husband, who agreed that yes, indeed, this was an odd coincidence, though he is accustomed to my enthusiasm and my dead friends.

The last document I was reading when I left was a letter home by Howard Fletcher Davidson, the marine from the northern Catskills of New York. I figured that maybe this was a sign that I should see what happened to him. For the next several days, I stalked old Fletch. On the Delaware County, New York Genealogy and History Site was an image, marked "Davidson—98," obviously not him because he was born in 1896. I contacted the *Catskill Mountain News* and, after some sleuthing and kind assistance from some old-timers in town, was given an e-mail address for an Ed Davidson. I fired off a note and several days later received the following e-mail:

> *Hello Bethany,*
> *I am the oldest son of HF Davidson and I live in La Jolla, CA. I will cc my brother, Richard who lives in Chula Vista, CA. Dad returned from WW1 and settled in his home town of Bovina Center, NY. He married Lois Jane Ormiston in October 1921 and they had seven children, four of whom survived birth. Dad worked many jobs as we were growing up, but was basically an electrician. Dad was "Bovina Town Historian" and the "Delaware County Historian" and an active genealogist.*

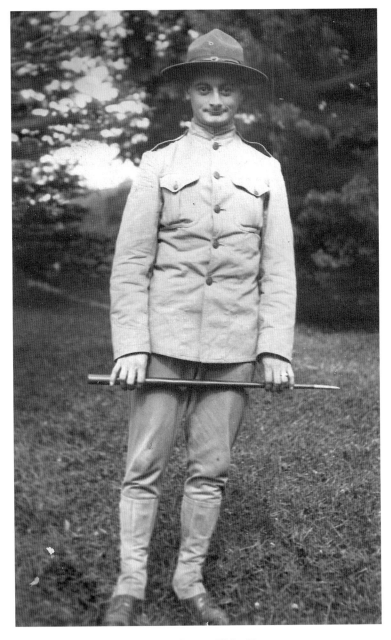

Howard Fletcher Davidson, 1918. *Courtesy Ed Davidson.*

*My brother Allan and I were on active duty [USAAC] in WW2
and [USAF] in Korea; Richard was USAF navigator with 24 years
of service.*

> *Thank you for your interest and good luck with your research. Please let
> us know if we can help with further information.*
> *Sincerely,*
>
> *Ed Davidson*

And with that, I closed the loop. Howard was happy, was loved and died
in 1987 at the ripe old age of ninety-two, with his children nearby. It was
deeply satisfying, and Ed and I have stayed in touch.

Still, that connection wasn't it, and it bothered me. I went to Newburyport
City Hall, downstairs to the Gold Star wall. There they were, a line of young
men from my city. Irish, Polish, heirs of the first settlers and first-generation
factory workers. And second from the right, I first saw Eben Bradbury's
solemn face. After a day or two in the library, at the historical society and
online, I had a rough outline of the facts of his life. It was interesting enough
to warrant a post on Facebook, which provided me with a few more useful
tidbits. I was told that his family had moved to California by 1930. Someone
sent me the Gold Star record for the state of Massachusetts, which provided
me with this gold mine:

> *Massachusetts Gold Star Record:*
> *Bradbury, Eben, Jr., Marine Corps: killed in action 12 June, 1918, in
> Chateau-Thierry sector* [Belleau Wood].
> *Enl. 17 April, 1917, Philadelphia, Pa.; assigned 1 May to Co. A; 3 June
> to 55th Co., 5th Regt., 2d Div. Overseas 3 July, 1917.*
> *Born 12 Nov., 1897, at Newburyport, son of Eben (of Heckman,
> Calif., 1924) and Elizabeth Chase (Bayley) Bradbury; brother of Mrs.
> Marguerite Todd Lampley. Kimball Union Academy, Meriden, N.H.,
> Class of 1916. Student at Newburyport High School at enlistment. Eben
> Bradbury, Jr., Triangle, Newburyport, named in his memory.*

And then someone sent me to Steve Bradbury, the venerable Stephen
H. Bradbury, a retired Newburyport firefighter, Korean War veteran
and font of local knowledge. I called his son, the deputy fire chief
of Newburyport, got his number and left a rambling message on his
voicemail. He called me back later that day and was happy to share
all the information he had. He was the first one to tell me that Eben's

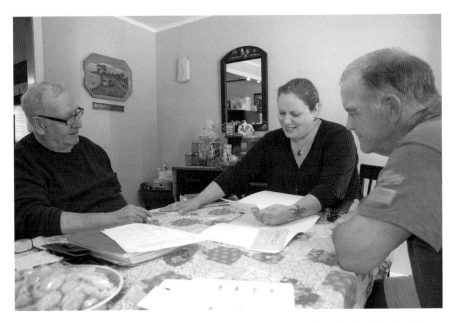

Bethany Dorau, Michael Johnson and Steve Bradbury meet together for the first time in August 2017 to look at all of their collected documents and artifacts. *Cynthia August Images.*

nickname was "Bunny." He told me about his connection to Eben; he became involved in the Veterans of Foreign Wars (VFW) after his service in Korea, the same post that was named after Eben in 1929. He was a relative of Eben's, but distantly; they both trace their common ancestry to Thomas and Mary Perkins Bradbury. He also told me there was someone in California who had visited Newburyport and had "some Bradbury things."

Steve Bradbury was in his eighties, and for decades, he and his brother had maintained a World War I artillery piece, a 1917 105 mm Howitzer that was one of many captured by American forces and brought back to the United States. Newburyport, like many cities and towns, requested a German artillery piece as a memorial, and in 1931, they were the recipients of one of the last memorial cannons in the United States Armory. On Armistice Day, November 11, 1931, the piece was dedicated and installed permanently in the Eben Bradbury Triangle. In my thirty-odd years of driving around Newburyport, I had missed not only a giant boulder with a plaque attached to it but also a World War I artillery piece in plain sight. It was a sobering reminder to pay better attention. Steve, his brother and a host of volunteers had not only maintained the gun but had also

restored it, made it safe and weather-tight and painstakingly replaced its wooden wheels. It was a labor of love, but he was no longer physically able to continue the work. Steve was deeply concerned that the meaning and significance of the gun would be lost and it would once again fall into disrepair. The gun needed a champion. Knowing nothing about the care and feeding of century-old Bulgarian field artillery, I took a deep breath and agreed. "It's just love and linseed oil," he said.

Steve had lived a long and rich life, but there was one more thing that remained to be done, and he was now aware that he would not be able to do it. The Newburyport service medal that Eben Bradbury Jr. was entitled to had been cast but left behind by his family at city hall. Eben and Lizzie were in no mood to deal with one more reminder, one more Hopkinson speech about the immortality of their son. The Bradbury Doyle VFW Post had been given the medal for safekeeping by the Veterans Affairs office, as Eben Jr. seemed to no longer have family in town, and when the VFW post merged with another, Steve volunteered to take the medal. It always felt wrong to him that Eben Jr. never had at least this bit of a homecoming, he said, his voice cracking. "I always wanted to let him know that Newburyport remembers him." He took a moment and then issued an order in the voice of a man who has just hit on a solution to a vexing problem: "You will take it to him in France." And I knew immediately that I would do just that. I didn't check my calendar or think about the cost or wonder where exactly

The Newburyport service medal given to all members of the armed forces upon their return from World War I. *Author's collection.*

the Aisne-Marne American Cemetery was and how I was going to get there. I just saw this sharp-eyed, beautiful boy, our boy, all those thousands of miles away, and the determination of this veteran, who had shared a taste of Eben Jr.'s experience, to remember him.

I called James, my husband of less than a year, and asked him if we could change our (belated) honeymoon plans to bring a medal to a grave in the middle of France. He agreed immediately—well, almost immediately. He would happily go to France with me if we could spend some time drinking beer in Belgium on the way. In May 2015, James and I went to Belgium and then on to Paris, where another bit

of luck came our way. Christopher Carrier, a high school friend of my former husband, is an army colonel stationed in Nuremburg, Germany. After hearing that we would be in France, he flew to Paris and rented a car, and early in the morning of May 10, we made our way out to the Aisne-Marne American Cemetery where Eben Bradbury Jr. is buried. It is hard to imagine the terrible destruction wrought in the villages around Château-Thierry. It is a picture postcard of French bucolic beauty, with neat, thatched cottages, undulating wheat fields and lush forests. The Aisne-Marne American Cemetery is forty-two gorgeous acres right at the foot of the hills where the heaviest fighting took place during the Battle of Belleau Wood. The approach to the cemetery takes you through woods, past undulating ground and trees that are strangely similar to one another. It looks for all the world like the aristocratic hunting preserve that it was in 1918, except once you know what happened here, all you can see is death. That rolling ground is what is left of hastily dug scrapes where marines tried to get under German machine gun fire, artillery craters and rifle pits. The trees are so similar because they are all the same age. The trees in this forest all died in June 1918, and new ones grew with shrapnel embedded in their trunks. The soil will stain your hands red, not because it is clay but because it is so full of rusted iron.

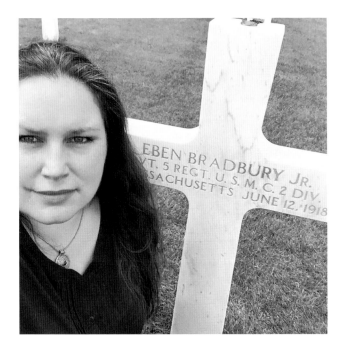

Bethany Dorau at the Aisne-Marne American Cemetery in May 2015 with Eben Bradbury Jr.'s headstone. *Author's collection.*

At the gatehouse of the cemetery, we met another guardian of Eben Jr.'s memory. His name is Constant Lebastard. Constant is the French assistant superintendent of the cemetery, and when I sent a blind e-mail to the general information mailbox of the American Battle Monuments Commission, which administers all the cemeteries of American servicemen on foreign soil, it made its way to him, and he was waiting to meet us when we arrived.

Constant took us out to Eben Jr.'s grave, carrying a bucket of sand. At the time, newly involved in his story, it was incredibly powerful to see his name in the field of white marble crosses and stars but also felt a bit intrusive. "Hello, Bunny," I said. "You don't know me, but I know you a little." Constant gently rubbed sand, collected from Omaha Beach in Normandy, over his headstone, bringing the engraving to life. Chris Carrier planted a flag, and we added some soil that we had pilfered from the front yard of his house at 67 Bromfield Street. We all stood, and I placed the medal from the City of Newburyport on his grave and told him that his city was thankful.

I asked my companions for a moment alone, and I sat down next to his stone and said some private words to Eben. It was a beautiful, warm day, and as I tried to be present in the moment, my phone buzzed. It was my son, wishing me a happy Mother's Day, and at that moment, the bells in the chapel began to ring. You may imagine a somber tune, in keeping with the scene, but the bells played "Yankee Doodle Dandy," a poignant reminder of the youth and good cheer of the lads marching to their death. After visiting the chapel, we visited the archives room, where files are kept on all 2,289 war dead buried there. We deposited the medal, still in its box, along with some pictures and all the vital records I had pulled about his life, and said our goodbyes.

I came home and wrote an article about the experience for the *Newburyport Daily News*, the same paper that had advertised a thousand miracle cures for scrofula and dandruff and lice for Eben Bradbury and published Eben Jr.'s bowling scores. I was hoping for some closure. I had done the thing, completed the mission and honored the dead. I tried to put the experience to bed, but I was unsettled and sad, and I had questions. Over half of the marines killed in the Battle of Belleau Wood were brought home and buried with their families. Why was he left there? Why was his service medal never picked up? Why did his family move to California after literally centuries in Newburyport, and what became of them there?

These questions, and a persistent feeling that the Bradburys weren't done with me yet, kept me on a low-level quest for more information. I looked for his family, found a record of Marguerite moving to California and deduced that the parents moved to California to be near her. I found pictures of Eben's and Lizzie's graves in the Acacia Memorial Park in Modesto, California. I turned next to Eben's military record, hoping that would answer some of the questions I had. The U.S. National Archives and Records Administration has a website that provides a great deal of information about service members, so long as they have been dead for more than one hundred years. I called, explained the situation and was asked if I was the next of kin, and when I said no, I was told that I could not access Eben's record until one hundred years after his death. I hung up and called Steve Bradbury, who told me how he was related to Eben (seventh cousin), and then went back to my genealogy, assembled over a lifetime by my great-aunt. Well, Steve may have the Bradbury name, but I have the benefit of centuries of inbreeding. Lizzie and I have four common ancestors, it turns out, on the Bayley side, with my mother his fifth cousin in one of those. So I thought that maybe fifth, once removed, could at least match seventh. I felt a little better about claiming kinship. I called back and said that I was indeed his relative. They asked again if I am next of kin. I hesitated. The woman on the other end of the phone sighed heavily. "Look," she said, "do you have good reason to believe you are his next of kin?" *Just say yes*, she said, under her breath. "Yes?" I said. It's a heavy thing to claim some special relationship with someone you have never met. I took some comfort in the fact that nobody had ever visited his grave in France or inquired about it. Nobody else had ever requested his records.

Eben Bradbury Jr.'s records arrived, with their faint typewriting and their military jargon, and I opened the envelope with mixed feelings. I was intruding, a stranger, but also a mother and a friend. The military record was, and is, a strangely intimate collection of documents. It was from these records that I was able to find information about his movements while in the marines, the nature of his illness in France and the shoddy handling of the reporting of his death. I also found the letters demanding an answer from his father about the final disposition of his body. Also contained in the packet was his physical exam, with fingerprints, his scars and identifying features noted. I also read that he had failed his small arms course and that his vision was poor. His path through France was catalogued in terse entries; our boy was in the trenches in Verdun, in eastern France, then steadily west, from Camp Montgirmont to Chatillion, to the fight that cost

him his life in Belleau Wood. In every entry, his character was given as "excellent" and the disposition of his body as unknown. One records card says simply, maddeningly, "Jack has his card." I received Eben's military file in June 2015, read it, processed it and put it aside, and my life galloped on at breakneck speed. I had as many answers as I was going to get. I waved at his rock every day, thought about him a lot and awoke from vivid, agonizing dreams of darkness and tangled brush and crawling, bleeding, the noise of heavy guns.

A year passed, exactly one year to the day since I had sat by Eben Jr.'s grave in France. On May 10, 2016, in my junk mail, there was an e-mail with the subject line "Eben Bradbury Information." It began, "Bethany, we have a small lavender farm and gift shop in California." Apparently, the daughter of the writer sometimes acquired items at auction to sell in the shop or for decoration, and when a friend of hers purchased a lot of books and letters at an estate sale in Modesto, she brought them into the shop. The owner, whose name is George, became intrigued by two bundles of letters tied up with string and bought them from his daughter. And since he's a modern man, he Googled the name on the top envelope and found the article I had written for the *Newburyport Daily News*. The name, of course, was Eben Bradbury. Would I take them and share them with Steve? I immediately e-mailed him back, offering to pay for shipping or fly to California to pick them up or anything. I think I was too eager because I didn't hear back, but three days later, a package arrived at my door. It was a hectic night, and I opened the box quickly, removing one letter from its worn envelope. It was from Eben Jr. and opened "Dear Folks." I put it away, had a little cry and promised to return to the letters when I could give them my full attention. Four days later, another box arrived in the mail. Apparently, George had hunted down more letters from the friend of his daughter and bought those too. George is another keeper.

Waiting until you have time is always a mistake. Thank goodness for my friend Leana, who was just as interested in this story as I was, and my husband and others who kept asking me when I was going to read the letters. I just couldn't. I wasn't ready to give them my full attention. Finally, in December, Leana had enough. Just give me the letters, she said, and I'll transcribe them and then we can get this party started. File boxes and acid-free folders were purchased, and we got to work with the help of Doris, another friend. We filed the letters. There are 306 of them. We made it through 3 letters that afternoon, and it was clear that we needed help. Leana offered her house, and I asked my friends and family if any of

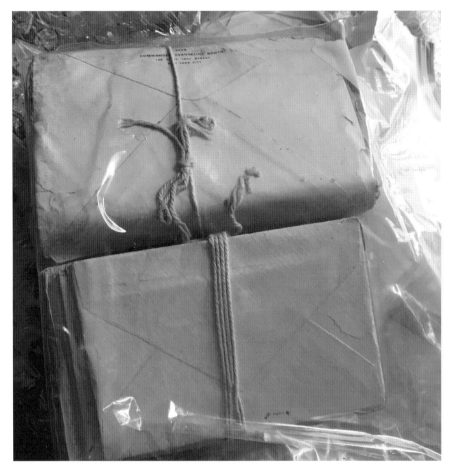

The Eben Bradbury letters as they arrived in May 2016 from California. *Author's collection.*

them would be interested in attending a transcription party. On December 28, fourteen people came over, took 1 letter at a time and transcribed it. By the end of the day, over 60 letters were done, and we knew just what a treasure we had. These letters had been collected over a lifetime by Eben, the pharmacist, and so they contained not only letters from Eben the marine but also his own letters that had been returned and collections of letters from other family members, including his father, Captain Eben, and his mother, Mary Todd. For eight hours, co-workers, neighbors, dear friends and friends of friends sat hunched over in silence, reading these letters, occasionally bursting out laughing or wiping a tear. I will never

forget it. That day, we all became his neighbors and his friends. We shared passages from feisty Marguerite, fussy Mary Todd and funny Captain Eben. In addition to letters, we found report cards, newspaper clippings, calling cards, contracts, all manner of paper ephemera. The oldest letter concerned a lawsuit from 1738. It was a treasure-trove. I called Steve to tell him about it. "Yes, fine," he said, "but have you checked on the gun?" He is a man of singular purpose.

Months more went by. I made a small repair to the handle on the gun and was very proud of myself. More letters were transcribed by friends and family and even a high school volunteer. The Bradbury family was reassembled from the pieces Eben had gathered when he left for California, and it was a pleasure getting to know them, even if the path to their story had begun with such a tragedy. I began to take notes, to follow people through the record, and a story began to emerge that seemed worth documenting. This book began to take shape.

It had always bothered me that Steve had told me there was someone else out there who had Bradbury information, but I hadn't managed to make a contact. Finally, knowing that I needed to put to rest the worry that I was missing more key information, I tracked down a phone number and an article for a man named Michael, who had visited Newburyport in 2008 with a collection of objects relating to the Bradbury family. As I was gathering letters and organizing and transcribing, I called several times. The voicemail was full. Finally, I accidentally called in the wee hours of the morning, forgetting about the time difference between coasts, and got a very sleepy Michael on the phone. His story was also extraordinary. He was a public school teacher and a lover of antiques and vintage collectibles. On weekends, as a young man, he would take trips to little towns and look for thrift stores and roadside stands and good fishing spots. In one town, he ran into the mayor, who suggested that rather than patronize the local thrift store, Michael should come check out his barn. In this barn was a large chest, filled with books, paintings, newspapers and other objects. Most of the items were terribly smoke- and water-damaged, moldy, thrown together. He bought the chest and its contents and tooled on home. Over the next few weeks, Michael realized that he had purchased a family's collection over centuries and called the mayor to arrange for its return. He was told that there was nobody to return it to. Michael had placed some objects, ships' logs and the like, with appropriate museums, but he had Eben the pharmacist's diaries from 1885 to 1934, along with Eben Jr.'s ribbons from Camp

Burley, Ebenezer's coins and silver spoons, some unidentified family and school photographs and other ephemera. He sent me some pictures, and I offered to fly to California to read the diaries and see the photographs, since at that point I only had the official portrait of Eben Jr. He was preparing for a family wedding, he said, and would perhaps be able to visit in a few months. I think he sensed the desperation in my voice, because the next day he sent me a message, telling me that he would be flying up the following weekend on the red-eye with everything he had.

On August 25, 2017, Michael arrived with a suitcase containing everything that remained from the trunk he had purchased thirty years before. Somehow, the story of this family had now inspired two trips across the country for him and one across the Atlantic for me. We spent the weekend poring over the letters I had from George the lavender farmer and the diaries Michael had brought. We sorted out generations of Eben Bradburys, traded objects, laughed and joked and became friends ourselves. It was an odd way to meet a person, but we already had a mutual friend. We went to see Steve together, visited the memorial stone and the graves of Captain Eben and Mary Todd and stood in front of 67 Bromfield. When Michael returned to California, he left behind the diaries, along with most of the photographs and a silver spoon, marked with the distinctive B, eagle and Indian of Bradbury and Sons silversmiths, and I gave him Captain Eben's letters from California. He is another keeper.

As I got to work transcribing Eben's diaries and reading two hundred years of letters and newspapers, the meaning of all this discovery, these strange coincidences, these new friends changed for me. This was no longer the story of a young marine who died a tragic death in France. It was the story of a family and a place, with Newburyport as a central character. For decades, as the great-aunts and uncles and cousins left Newburyport, they had shipped themselves back, and Eben had met their bodies at the station, arranged for their headstones to be carved and placed and visited their graves, making careful notes in his diary. His father had hunted down

				STANISLAUS COUNTY						
Bigelow, Mrs. Jane	Route #2, Box 247, Turlock		Mother	Bigelow, Gordon	Pvt.1/c	120th Field Hosp.		Meuse-Argonne	No	
Boardman, Mrs. Sadie G.	133 Virginia Ave., Modesto		Mother	Boardman, Guy W.	Pvt.1/c	Co. A, 59th Infantry		Meuse-Argonne	No	
Bradley, Mrs. Eben	P.O. Box #1234 Modesto		Mother	Bradbury, Eben,Jr.,	Pvt.	80th Co., 5th Regt., USMC		Aisne-Marne	Unknown	
Larson, Mrs. Emily	Patterson		Mother	Larson, Gustaf L.	Wag.	Battery E, 339th F. A.		Aisne-Marne	Unknown	
Owen, Mrs. Elizabeth S.	R #1, Bx. #138, Turlock		Mother	Owen, Henry H.	Pvt.1/c	Co. D, 353rd Infantry		Meuse-Argonne	No	
Tosh, Mrs. John	Faith Home, Ceres		Mother	Tosh, Peter Edgar	Pvt.	Co. M, 305th Infantry		Meuse-Argonne	No	
Tyrrell, Mrs. Josephine	219 Roselawn Ave., Modesto		Mother	Tyrrell, Harold H.	Pvt.	Co. M, 47th Infantry		Aisne-Marne	Yes	
Watkins, Mrs. Amanda	Route 1, Ceres		Mother	Watkins, Charles H.	Pvt.	Co. H, 307th Infantry		Meuse-Argonne	No	

Gold Star listing for Eben Bradbury Jr. *Newburyport Public Library.*

dead relatives for his brother's book. It was heartbreaking to know that when his own son, who was so beloved, died in a field far away, Eben was too heartbroken and angry to perform these same final acts of love for him. If I believed in messages from beyond the grave, which I don't, I would say that Eben may have regretted leaving his son unvisited, without the comfort of the ancestors around him, in the soil of the city to which they all returned. Lizzie may have wished, when it was too late, that she had taken the Gold Star trip across the ocean to see where her boy spent his last days. What I do believe is that the human experience is a mysterious and complicated thing, and sometimes the choices we make and the bits of ourselves we leave behind—ordinary things like newspapers and spoons—form a path that a sympathetic soul may travel. I did not have Eben's letters to his son, the ones marked "Killed in Action," when I first visited his grave. I will return, and this time, I will read him all the news from his family at 67 Bromfield.

BIBLIOGRAPHY

Asprey, Robert B. *At Belleau Wood*. Denton: University of North Texas Press, 1996.

Axelrod, Alan. *Miracle at Belleau Wood: The Birth of the Modern U.S. Marine Corps*. Guilford, CT: Lyons Press, 2007.

Bayley, William H. *History of the Marine Society of Newburyport: From Its Incorporation in 1772...to the Year 1906*. Newburyport, MA: Press of the Daily News, 1906.

Bradbury, John Merrill. *Bradbury Memorial: Records of Some of the Descendants of Thomas Bradbury*. Portland, ME: Brown, Thurston and Company, 1890.

Camp, Richard D. *The Devil Dogs at Belleau Wood: U.S. Marines in World War I*. St. Paul, MN: MBI, 2008.

Catlin, Albertus W., and Walter A. Dyer. *With the Help of God and a Few Marines*. New York: Doubleday, Page and Company, 1919.

History of the Town of Milford, Worcester County, Massachusetts: From Its First Settlement to 1881. Milford, MA: Town of Milford, 1882.

Nelson, James Carl. *I Will Hold: The Story of USMC Legend Clifton B. Cates, from Belleau Wood to Victory in the Great War*. New York: New American Library, an imprint of Penguin Random House LLC, 2016.

Second Division, American Expeditionary Force in France, 1917–1919. New York: Hillman Press, 1937.

Yingling, James M., and John Haskell Kemble. *A Brief History of the 5th Marines*. Washington, D.C.: Historical Branch, G-3 Division Headquarters, U.S. Marine Corps Washington, D.C. 20390, 1968.

INDEX

A

American Legion 131
American Red Cross 15, 16, 94, 130
Archduke Franz Ferdinand 19, 92

B

Barnett, General George 104, 108
baseball 15, 48, 54, 56, 70, 74, 76,
 81, 83, 86, 91, 92, 93, 95, 97,
 98, 102, 104, 124
Bayley
 Frank 64, 65
 Harry 64, 76
 Lizzie 13, 16, 54, 56, 59, 62, 63,
 64, 65, 68, 69, 70, 71, 72, 73,
 76, 80, 81, 83, 93, 96, 102,
 109, 119, 126, 127, 130, 131,
 133, 134, 144
 Lucy Chase 54, 91
 William H. 54, 65, 70, 111

Belleau Wood 115, 117, 118, 119,
 120, 121, 122, 123, 126, 129,
 135, 137, 139, 142, 143, 145
Blanchfield, Captain John 118
bowling 93, 97, 98, 103, 131, 143
Bradbury
 Albert E. 78, 83
 Albert F. 33, 37, 42, 43, 51, 53,
 67, 77
 Anna Mary 24, 79, 80
 Captain Eben 14, 29, 30, 32, 35,
 36, 37, 40, 41, 42, 45, 49, 51,
 53, 54, 56, 78, 82, 87, 146,
 147, 148
 Ebenezer, I 23, 40, 79
 Eben, III 13, 14, 19, 24, 39, 40,
 43, 45, 47, 48, 53, 71, 72, 73,
 78, 79, 81, 82, 83, 93, 108,
 111, 119, 124, 126, 127, 128,
 130, 131, 133, 134, 148
 Eben, IV 13, 14, 68, 72, 74, 76,
 77, 78, 80, 81, 86, 87, 88, 92,
 93, 94, 95, 97, 98, 101, 102,

103, 104, 105, 106, 107, 109,
111, 113, 115, 118, 119, 120,
121, 122, 123, 127, 129, 131,
143, 144
Emily 78
Frances 77, 82
Harriett 38, 39, 67
John 31, 38
John Merrill 27, 29, 30, 31, 32,
34, 35, 37, 38, 41, 42, 43, 51,
53, 60, 61, 133
Jonathan 22
Marguerite Todd 16, 65, 68, 69,
71, 74, 76, 77, 80, 81, 82, 85,
86, 87, 89, 91, 92, 93, 94,
96, 97, 98, 99, 101, 103, 110,
111, 123, 126, 129, 130, 131,
133, 134, 139, 144, 147
Mary Perkins 20, 21, 87, 140
Sarah 39
Steve 139, 140, 144
Theophilus 21, 22, 23, 24
Thomas 20, 21
Walter Scott 39
Wymond 21, 22, 60

C

California
China Flat 34
Downieville 31
Hickman 16, 130, 131, 133, 134
Modesto 133
Camp Burley 86, 87, 92, 93, 127,
133, 148
cemeteries
Aisne-Marne American 134, 141,
142

Oak Hill 53, 67, 82, 83, 87, 133
Old Hill 43, 44, 61, 81, 87, 133
Chain Bridge 76, 81, 93
Christian Endeavor 85
Colby College 92, 110, 123
Committee on Public Safety 99
Cooke, Lieutenant Elliot 15, 119,
121, 122, 128

D

Davidson, Howard Fletcher 136

F

Fifty-Fifth Company 15, 137
football 91, 97, 98, 127
Frankfort, Maine 23, 40

G

gold mining 14, 32
Gold Star Mothers 134
Gordon's Rest 87

H

Heavey, Elizabeth Horton 55
Hopkinson, Walter 98, 102, 126,
127, 130, 131, 141

J

Johnson, Frank 87
Joppa Flats 81

K

Kimball Union Academy 93, 96, 139

L

Little, Eleanor 16
Lufkin, W.W. 107, 126

M

Merrill, Nancy 23, 24, 25, 33, 40

N

New Bedford 25, 27, 29, 31
Newburyport
American Expeditionary Forces 15
Titcomb and Lunt's mast yard 32
United States Army Second
Division 109
newspapers
Newburyport Daily News 78, 97,
119, 128, 143, 145
Newburyport Herald 23, 26

O

Old South Church 37, 69, 82, 83,
85, 102, 130

P

Parker River 86
Pershing, General John 111, 119, 135
pharmacies
Atkinson 46
Charles G. Reed 48
Eldbridge Nash 51, 55, 56
Longfellow and Company 47, 48
Philadelphia Navy Yard 102, 105, 107
Plum Island 56, 64, 68, 69, 74, 76,
78, 85, 97
Portland, Maine 93
Pure Food and Drug Act 47, 79

S

Salisbury 19, 20, 21, 40, 56, 59, 64,
69, 74, 87, 93
Salisbury Beach 56, 64, 69
school
High and Putnam Free 45
Jackman 92
Newburyport High 19, 91, 92,
93, 97, 102, 103, 139
ships
Antarctic 29
Eschol 40
Merrimac 25, 26
Susan 27
Wade 27
silversmith 24, 40, 133

T

Tappan, Mary 24, 30, 33
Todd, Mary 14, 27, 29, 30, 32, 35,
 37, 38, 39, 40, 45, 47, 48, 51,
 55, 56, 62, 63, 64, 65, 67, 69,
 70, 71, 77, 78, 80, 81, 82, 83,
 93, 146, 148

U

United States Marine Corps 108
Uplift Publishing Company 92

W

war
 Civil War 40, 42, 49, 60, 69, 73, 99
 Spanish-American War 69
whaling 14, 25, 40, 41, 42
whist 64, 65, 68, 70, 72, 81
Williams, George 49, 53
Wise, Major Fredrick 120
Woman's Christian Temperance
 Union (WCTU) 79

ABOUT THE AUTHOR

Bethany Groff Dorau is the author of *A Brief History of Old Newbury* (The History Press) and a primary contributor to the Defining Documents in American History Series. She is the North Shore regional site manager for Historic New England, based at the Spencer-Peirce-Little Farm in Newbury, and a recipient of the Pioneer in Preservation Award from the Essex National Heritage Commission and the North of Boston CVB Leadership Award. Bethany sits on the boards of the North of Boston CVB, the Newburyport Preservation Trust and the planning committee of the Newburyport Literary Festival. She has published articles in the *New England Quarterly*, the *Encyclopedia of American History* and *Historic New England* magazine. She holds an MA in history from the University of Massachusetts and lives in West Newbury with her family.

Visit us at

www.historypress.com